Drawing Us In

Drawing Us In

How We Experience Visual Art

A Beacon Anthology

Deborah Chasman and **Edna Chiang,** Editors

Beacon Press
Boston

Beacon Press
25 Beacon Street
Boston, Massachusetts 02108-2892
www.beacon.org

Beacon Press books
are published under the auspices of
the Unitarian Universalist Association of Congregations.

05 04 03 02 01 8 7 6 5 4 3 2 1

This book is printed on acid-free paper that meets the uncoated paper
ANSI/NISO specifications for permanence as revised in 1992.

Composition by Wilsted & Taylor Publishing Services

Library of Congress Cataloging-in-Publication Data
Drawing us in : how we experience visual art / Deborah Chasman and Edna
Chiang, editors.
 p. cm.—(A Beacon anthology)
 ISBN 0-8070-6606-0 (cloth)
 ISBN 0-8070-6607-9 (pbk.)
 1. Art. 2. Experience. I. Chasman, Deborah. II. Chiang, Edna. III. Series.
 N62.D73 2000
 700—dc21 99-086940

contents

Nothing is more tiresome to read, generally, than the epiphany recalled, especially when it's in the service of jump-starting the brief reminiscence. "Nothing" is perhaps too dramatic a word to offer here, but one employs it as an antidote to the empty tinfoil sheen and shimmer that emanates from the revelation offered for effect. And then I knew, such a revelation might begin or end. Then I was certain, another essayist might begin. Or, cutting to the chase: After that, I knew nothing would be the same.

Life, as it happens, too often proves that nothing is ever the same, not once. The essayist who can denote when and where their being and thought process was irrevocably changed by a single aesthetic experience is writing movie fiction, not an essay, which is about process. In the former, life and the experience of looking is explicated in a series of scenes, as no real life can be, or is: Camera sees X, a writer and artist, in extreme close-up. A moment of comprehension about all the world's wonders and his place in it suddenly flashes in his eyes, as he stands in front of Michelangelo's *David*. The camera swirls. X and the statue are one.

But when the camera doesn't swirl, and we are made aware, through a different means of communication (the literary essay), of the accretion

of time and life experience that we bring to any given work of art seriously considered, we trust the essayist in a way that we can never trust, say, Vincente Minnelli's *Lust for Life*, his bio-pic of Vincent van Gogh's last years, which he apparently spent wrestling with the crows at Arles, among other things. The film is heartfelt and earnest, but what does Ruskin bring to the art of looking that M-G-M never could? And why has the experience of looking at art and writing about its transformative properties not become a larger part of the discourse about art and artists, like Vincente Minnelli's *Lust for Life*? It's because of death. In the movies, as I've said before, life is explication. Movie deaths get even less play. Movies do not like to show death at work. The movies (the plastic art's only rival in the mass and individual experience of looking) shows someone killed or cutting off their ear and in bed, dying, but it's very rare to see the effect that time and experience has on any of us. It kills us. We learn more as we move toward death. Each experience is a killer that manages mostly not to kill us and leaves us, somehow, a little less alive and panting, saying of this or that work or show or exhibition: I was knocked out by it; I couldn't get over it. What I saw—I could barely look at it, it was so powerful. I could barely look at it and I did and it prompted a response is, I think, the general subtext of many of the very best pieces written about the alchemy that takes place between the viewer and the thing viewed. It's so silent an experience, and so visceral, no amount of psychoanalysis can cure confirmed art watchers of their obsession, or make them take the talking cure to get over it, no matter how many essays they write. Looking and responding to art prompts generous responses, or should. At least it does in the very best art critics and essayists. It's charming—their impulse to share what they felt the artist's intention was, no matter how private the exchange of looking has been for them. Look at this! they exclaim, stumbling out of the gallery or museum. Can you imagine? The point is that great works of art—or, at any rate, those that provoke an impassioned response—haven't been imagined before, can't be accounted for, won't be classified. And one's imagination keeps worrying at its surface and intent, saying this and that, knowing that saying this or that hardly matters at all. What matters is this: that, despite being dissected and loved, the particular artwork under review retains its mystery while further deepening the mystery we call the collective experience of living.

However, the art that affects us and attacks us with the artist's passion and dreams is something we've seen before, somewhere, if only we could place it. It's a matter of how deeply one has ever looked at one's interior world: it's been there all along. Art is mortality made manifest. We won't last, but this painting or drawing, sculpture or photograph will. In Delmore Schwartz's masterful piece, "In Dreams Begin Responsibilities," we're part of the audience watching the film of the artist's life. We know that when his film is over, death will have begun. When any of us says that a so-and-so work helped alter perspective about life and art (generally intertwined), we're saying that not only is it beautiful, but its beauty will outlast us and we don't even resent it for that. Does the great or famous work of art remember its viewers, long after they've passed from view? I'm a great believer in the aura surrounding a work of art. I don't mean the vicissitudes of connoisseurship, but what we've projected on that lone and defenseless work: all the days of our lives. How can that painting or sculpture bear it? Wearing the patina of all that feeling and debate? Its mere existence is a testament to death's inability to erode the surface of the artist's spirit, which is what we see right there, on the surface of things.

Hilton Als

Peter Schjeldahl

A Theft in Norway

March 8, 1994

A blurry surveillance tape showed two men schlepping a painting out a second-floor window and down a ladder. One man fell off the ladder. I had mixed feelings, watching this on network news. I would not have wept to see the thieves break their necks—some other time. But while the painting was at risk, I wanted them to be pulled-together cat burglars, not gravity-challenged Bozos. I wished the jerks finesse.

The place was the National Gallery of Norway in Oslo. The painting was Edvard Munch's *The Scream*. *The Scream* turned one hundred years old last autumn. It is a terrifyingly delicate object, three feet high by about two and a half wide, that is made of oil paint, pastel chalk, and milk-based casein paint on a piece of cardboard. It is infinitely precious to me and, I think, to everybody everywhere forever, whether they know it or not.

Would the theft have become television news without the slapstick video? Days passed with no further word in any of the media, and the networks remained mute when, at last, newspapers reported hints that the painting was being held hostage by antiabortion fanatics. The ransom was to be propaganda: a broadcast on Norwegian television of the antiabortion shockumentary, *The Silent Scream*. It appeared that Munch's painting had fallen victim to the coincidence of its title in English.

1

The painting's fame also made it a target, of course, though the paucity of news coverage confused me on this score. Didn't anyone care? Then it occurred to me that in most people's minds *The Scream* is only abstractly, if at all, a unique, hand-made object. It is, rather, an *image:* that distended, flayed, wormish, homonuclear mask of absolute terror. Images can't be humped out of windows. They are everywhere and nowhere. You can't steal something that exists in thousands of reproductions, cartoons, joke greeting cards, and, lately, inflatable toys.

Many people find the image irresistibly comical, perhaps as an essence of over-the-topness: *too much.* Derision of it may be self-protective. A joke is the epitaph of a feeling, Nietzsche said. The feeling buried beneath amusement at *The Scream* is particular and universal dread. Who wouldn't resort to a callous chuckle to evade *that?* But you can't patronize the image when in front of the physical painting, because then it is no longer just an image. It is a fact. Step up to *The Scream,* if ever again you get the chance, and look long and hard. Laughter will die in your throat.

The Scream and other Munch originals changed my life when I saw them in a big show at the National Gallery in Washington in 1979. The experience confirmed me as an art critic. I wanted a piece of the difficult glory revealed by Munch, a power that can be wielded only through being shared. Like most Americans, I had had no idea of Munch's chops as a painter, really knowing only his prints (including uneven versions of *The Scream* with which he started the debasement of his own creation). Nearly all his paintings are in Norway. (Nazis sold off German collections of his "degenerate" work there during the war.) I have since been three times to Oslo and the cavernous museum hall, hung with his masterpieces, that is to me holy ground.

My sudden devotion was partly self-involved. My ancestry is Norwegian. People kept telling me I looked like Munch. I wrote a long essay on him and for a while almost fancied I *was* him. I got over the infatuation but not the romance, which gave me lasting instruction in how art works.

The Scream tells very exactly a truth of the easiest thing in the world to lie about: pure subjectivity. It culminated two years of Munch's constant effort to convey a personal event of 1891. In his words: "Stopping, I leaned against the railing, almost dead with fatigue. Out over the blue-

black fjord hung clouds like blood and tongues of fire. My friends walked away and, alone, trembling with fear, I became aware of the great, infinite scream of nature."

Early treatments of the epiphany show a man hunched over the railing. Only the whiplashing red and yellow sunset and writhing landscape are active. Then it came to him, a figure formed of the rhythms of earth, sea, and sky: all of the nature in a person undulating in sync with a cruel universe. The self-consciousness of the person registers what is happening—ego-death, for starters—and reacts appropriately, venting a scream that never began and will never end.

Munch, twenty-nine years old when he painted *The Scream*, was one strung-out young genius in the 1890s: alcoholic, agoraphobic, a compulsive traveler, a tormented lover. (He crashed in the 1900s, salvaged himself, and worked at reduced steam until his death in 1944.) He had a rockstar-like career then, especially in Germany, that only exacerbated the pressure he put on himself to be, as he said in 1892, "the body through which today's thoughts and feelings flow." The disasters of his reckless ways gave him sensational subjects that he distilled with care, augmenting his inventiveness with lessons from van Gogh, Gauguin, and other contemporaries.

In person, the rawness of *The Scream*'s savagely worked surface astounds. Nothing about it bespeaks "finish." But nothing suggests sloppy "self-expression" either. There is terrific, deliberated terseness in each element, such as the wrenching clash between the frontal, wavering bands of the sky and the hard lines of the railing in fleeing perspective. Space turns inside-out, near and far exchanging places. A killer detail is the pair of figures obliviously walking away, affirming that the scream is inaudible.

Munch penciled faintly on one of the painting's red stripes, "Only someone insane could paint this!" The picture is not personal. It is a pivot from the Naturalism and Positivism of the nineteenth century into a century of one damned thing after another. It is a beautiful work for its color and drawing, its fragility, and its discipline. It is like a flame into which the artist, mothlike, fed himself. The flame will keep burning while the painting survives.

As long as *The Scream* hangs somewhere on a wall accessible to the

public, humanity will lack one alibi for being stupid about life, art, and the human cost of modernity—in a phrase of Kierkegaard's, "the dizziness of freedom."

There was the painting, a grainy gray rectangle on the television screen, coming out the window. The sight was like a kick in the stomach. It was crazy. It got crazier with the news that the perpetrators might be right-to-life. What sort of life do such people have in mind? To be preserved before birth for no end of barbaric abuse later? But it doesn't matter who they are, or what their reasons. They stole our picture and should fall from higher ladders.

On Romare Bearden

In 1965, as a twenty-year-old poet living in a rooming house in Pittsburgh, I discovered Bessie Smith and the blues. It was a watershed event in my life. It gave me a history. It provided me with a cultural response to the world as well as the knowledge that the text and content of my life were worthy of the highest celebration and occasion of art. It also gave me a framework and an aesthetic for exploring the tradition from which it grew. I set out on a continual search for ways to give expression to the spiritual impulse of the African-American culture which had nurtured and sanctioned my life and ultimately provided it with its meaning. I was, as are all artists, searching for a way to define myself in relation to the world I lived in. The blues gave me a firm and secure ground. It became, and remains, the wellspring of my art.

In 1977, I made another discovery which changed my life. I discovered the art of Romare Bearden. I was then a thirty-two-year-old poet who had taken his aesthetic from the blues but was unsure how to turn it into a narrative that would encompass all the elements of culture and tradition—what Baldwin had so eloquently called "the field of manners and ritual of intercourse" that sustains black American life. My friend Claude Purdy had purchased a copy of *The Prevalence of Ritual*, and one night, in

the fall of 1977, after dinner and much talk, he laid it open on the table before me. "Look at this," he said. "Look at this." The book lay open on the table. I looked. What for me had been so difficult, Bearden made seem so simple, so easy. What I saw was black life presented on its own terms, on a grand and epic scale, with all its richness and fullness, in a language that was vibrant and which, made attendant to everyday life, ennobled it, affirmed its value, and exalted its presence. It was the art of a large and generous spirit that defined not only the character of black American life, but also its conscience. I don't recall what I said as I looked at it. My response was visceral. I was looking at myself in ways I hadn't thought of before and have never ceased to think of since.

In Bearden I found my artistic mentor and sought, and still aspire, to make my plays the equal of his canvases. In two instances his paintings have been direct inspirations. My play *Joe Turner's Come and Gone* was inspired by Bearden's *Mill Hand's Lunch Bucket*, a boardinghouse setting in Pittsburgh. I tried to incorporate all of the elements of the painting in the play, most notably the haunting and brooding figure at its center, whom I named Herald Loomis. The names of the characters, Seth and Bertha, were taken from another Bearden painting, *Mr. Seth and Miss Bertha*. The title of my play *The Piano Lesson* was taken from a painting of the same title.

I never had the privilege of meeting Romare Bearden. Once I stood outside 357 Canal Street in silent homage, daring myself to knock on his door. I am sorry I didn't, for I have never looked back from that moment when I first encountered his art. He showed me a doorway. A road marked with signposts, with sharp and sure direction, charting a path through what D. H. Lawrence called the "dark forest of the soul." I called to my courage and entered the world of Romare Bearden and found a world made in my image. A world of flesh and muscle and blood and bone and fire. A world made of scraps of paper, of line and mass and form and shape and color, and all the melding of grace and birds and trains and guitars and women bathing and men with huge hands and hearts, pressing on life until it gave back something in kinship. Until it gave back in fragments, in gesture and speech, the colossal remnants of a spirit tested through time and the storm and the lash. A spirit conjured into being, un-

broken, unbowed, and past any reason for song—singing an aria of fault-less beauty and unbridled hope.

I have often thought of what I would have said to him that day if I had knocked on his door and he had answered. I probably would just have looked at him. I would have looked, and if I were wearing a hat, I would have taken it off in tribute.

Dorothy Allison

This Is Our World

The first painting I ever saw up close was at a Baptist church when I was seven years old. It was a few weeks before my mama was to be baptized. From it, I took the notion that art should surprise and astonish, and hopefully make you think something you had not thought until you saw it. The painting was a mural of Jesus at the Jordan River done on the wall behind the baptismal font. The font itself was a remarkable creation—a swimming pool with one glass side set into the wall above and behind the pulpit so that ordinarily you could not tell the font was there, seeing only the painting of Jesus. When the tank was flooded with water, little lights along the bottom came on, and anyone who stepped down the steps seemed to be walking past Jesus himself and descending into the Jordan River. Watching baptisms in that tank was like watching movies at the drive-in, my cousins had told me. From the moment the deacon walked us around the church, I knew what my cousin had meant. I could not take my eyes off the painting or the glass-fronted tank. It looked every moment as if Jesus were about to come alive, as if he were about to step out onto the water of the river. I think the way I stared at the painting made the deacon nervous.

The deacon boasted to my mama that there was nothing like that baptismal font in the whole state of South Carolina. It had been designed,

he told her, by a nephew of the minister—a boy who had gone on to build a shopping center out in New Mexico. My mama was not sure that someone who built shopping centers was the kind of person who should have been designing baptismal fonts, and she was even more uncertain about the steep steps by Jesus' left hip. She asked the man to let her practice going up and down, but he warned her it would be different once the water poured in.

"It's quite safe though," he told her. "The water will hold you up. You won't fall."

I kept my attention on the painting of Jesus. He was much larger than I was, a little bit more than life-size, but the thick layer of shellac applied to protect the image acted like a magnifying glass, making him seem larger still. It was Jesus himself that fascinated me, though. He was all rouged and pale and pouty as Elvis Presley. This was not my idea of the son of God, but I liked it. I liked it a lot.

"Jesus looks like a girl," I told my mama.

She looked up at the painted face. A little blush appeared on her cheekbones, and she looked as if she would have smiled if the deacon were not frowning so determinedly. "It's just the eyelashes," she said. The deacon nodded. They climbed back up the stairs. I stepped over close to Jesus and put my hand on the painted robe. The painting was sweaty and cool, slightly oily under my fingers.

"I liked that Jesus," I told my mama as we walked out of the church. "I wish we had something like that." To her credit, Mama did not laugh.

"If you want a picture of Jesus," she said, "we'll get you one. They have them in nice frames at Sears." I sighed. That was not what I had in mind. What I wanted was a life-size, sweaty painting, one in which Jesus looked as hopeful as a young girl—something otherworldly and peculiar, but kind of wonderful at the same time. After that, every time we went to church I asked to go up to see the painting, but the baptismal font was locked tight when not in use.

The Sunday Mama was to be baptized, I watched the minister step down into that pool past the Son of God. The preacher's gown was tailored with little weights carefully sewn into the hem to keep it from rising up in the water. The water pushed up at the fabric while the weights tugged it down. Once the minister was all the way down into the tank,

the robe floated up a bit so that it seemed to have a shirred ruffle all along the bottom. That was almost enough to pull my eyes away from the face of Jesus, but not quite. With the lights on in the bottom of the tank, the eyes of the painting seemed to move and shine. I tried to point it out to my sisters, but they were uninterested. All they wanted to see was Mama.

Mama was to be baptized last, after three little boys, and their gowns had not had any weights attached. The white robes floated up around their necks so that their skinny boy bodies and white cotton underwear were perfectly visible to the congregation. The water that came up above the hips of the minister lapped their shoulders, and the shortest of the boys seemed panicky at the prospect of gulping water, no matter how holy. He paddled furiously to keep above the water's surface. The water started to rock violently at his struggles, sweeping the other boys off their feet. All of them pumped their knees to stay upright and the minister, realizing how the scene must appear to the congregation below, speeded up the baptismal process, praying over and dunking the boys at high speed.

Around me the congregation shifted in their seats. My little sister slid forward off the pew, and I quickly grabbed her around the waist and barely stopped myself from laughing out loud. A titter from the back of the church indicated that other people were having the same difficulty keeping from laughing. Other people shifted irritably and glared at the noisemakers. It was clear that no matter the provocation, we were to pretend nothing funny was happening. The minister frowned more fiercely and prayed louder. My mama's friend Louise, sitting at our left, whispered a soft "Look at that" and we all looked up in awe. One of the hastily blessed boys had dog-paddled over to the glass and was staring out at us, eyes wide and his hands pressed flat to the glass. He looked as if he hoped someone would rescue him. It was too much for me. I began to giggle helplessly, and not a few of the people around me joined in. Impatiently the minister hooked the boy's robe, pulled him back, and pushed him toward the stairs.

My mama, just visible on the staircase, hesitated briefly as the sodden boy climbed up past her. Then she set her lips tightly together, and reached down and pressed her robe to her thighs. She came down the

steps slowly, holding down the skirt as she did so, giving one stern glance to the two boys climbing past her up the steps, and then turning her face deliberately up to the painting of Jesus. Every move she made communicated resolution and faith, and the congregation stilled in respect. She was baptized looking up stubbornly, both hands holding down that cotton robe while below, I fought so hard not to giggle, tears spilled down my face.

Over the pool, the face of Jesus watched solemnly with his pink, painted cheeks and thick, dark lashes. For all the absurdity of the event, his face seemed to me startlingly compassionate and wise. That face understood fidgety boys and stubborn women. It made me want the painting even more, and to this day I remember it with longing. It had the weight of art, that face. It had what I am sure art is supposed to have—the power to provoke, the authority of a heartfelt vision.

I imagine the artist who painted the baptismal font in that Baptist church so long ago was a man who did not think himself much of an artist. I have seen paintings like his many times since, so perhaps he worked from a model. Maybe he traced that face off another he had seen in some other church. For a while, I tried to imagine him a character out of a Flannery O'Connor short story, a man who traveled around the South in the fifties painting Jesus wherever he was needed, giving the Son of God the long lashes and pink cheeks of a young girl. He would be the kind of man who would see nothing blasphemous in painting eyes that followed the congregation as they moved up to the pulpit to receive a blessing and back to the pews to sit chastened and still for the benediction. Perhaps he had no sense of humor, or perhaps he had one too refined for intimidation. In my version of the story, he would have a case of whiskey in his van, right behind the gallon containers of shellac and buried notebooks of his own sketches. Sometimes, he would read thick journals of art criticism while sitting up late in cheap hotel rooms and then get roaring drunk and curse his fate.

"What I do is wallpaper," he would complain. "Just wallpaper." But the work he so despised would grow more and more famous as time passed. After his death, one of those journals would publish a careful con-

sideration of his murals, calling him a gifted primitive. Dealers would offer little churches large sums to take down his walls and sell them as installations to collectors. Maybe some of the churches would refuse to sell, but grow uncomfortable with the secular popularity of the paintings. Still, somewhere there would be a little girl like the girl I had been, a girl who would dream of putting her hand on the cool, sweaty painting while the Son of God blinked down at her in genuine sympathy. Is it a sin, she would wonder, to put together the sacred and the absurd? I would not answer her question, of course. I would leave it, like the art, to make everyone a little nervous and unsure.

I love black-and-white photographs, and I always have. I have cut photographs out of magazines to paste in books of my own, bought albums at yard sales, and kept collections that had one or two images I wanted near me always. Those pictures tell me stories—my own and others, scary stories sometimes, but more often simply everyday stories, what happened in that place at that time to those people. The pictures I collect leave me to puzzle out what I think about it later. Sometimes, I imagine my own life as a series of snapshots taken by some omniscient artist who is just keeping track—not interfering or saying anything, just capturing the moment for me to look back at it again later. The eye of God, as expressed in a Dorothea Lange or Wright Morris. This is the way it is, the photograph says, and I nod my head in appreciation. The power of art is in that nod of appreciation, though sometimes I puzzle nothing out, and the nod is more a shrug. No, I do not understand this one, but I see it. I take it in. I will think about it. If I sit with this image long enough, this story, I have the hope of understanding something I did not understand before. And that, too, is art, the best art.

My friend Jackie used to call my photographs sentimental. I had pinned them up all over the walls of my apartment, and Jackie liked a few of them but thought on the whole they were better suited to being tucked away in a book. On her walls, she had half a dozen bright prints in bottle-cap metal frames, most of them bought from Puerto Rican artists at street sales when she was working as a taxi driver and always had cash in her

pockets. I thought her prints garish and told her so when she made fun of my photographs.

"They remind me of my mama," she told me. I had only seen one photograph of Jackie's mother, a wide-faced Italian matron from Queens with thick, black eyebrows and a perpetual squint.

"She liked bright colors?" I asked.

Jackie nodded. "And stuff you could buy on the street. She was always buying stuff off tables on the street, saying that was the best stuff. Best prices. Cheap skirts that lost their dye after a couple of washes, shoes with cardboard insoles, those funky little icons, weeping saints and long-faced Madonnas. She liked stuff to be really colorful. She painted all the ceilings in our apartment red and white. Red-red and white-white. Like blood on bone."

I looked up at my ceiling. The high tin ceiling was uniformly bloody when I moved in, with paint put on so thick, I could chip it off in lumps. I had climbed on stacks of boxes to paint it all cream white and pale blue.

"The Virgin's colors," Jackie told me. "You should put gold roses on the door posts."

"I'm no artist," I told her.

"I am," Jackie laughed. She took out a pencil and sketched a leafy vine above two of my framed photographs. She was good. It looked as if the frames were pinned to the vine. "I'll do it all," she said, looking at me to see if I was upset.

"Do it," I told her.

Jackie drew lilies and potato vines up the hall while I made tea and admired the details. Around the front door she put the Virgin's roses and curious little circles with crosses entwined in the middle. "It's beautiful," I told her.

"A blessing," she told me. "Like a bit of magic. My mama magic." Her face was so serious, I brought back a dish of salt and water, and we blessed the entrance. "Now the devil will pass you by," she promised me.

I laughed, but almost believed.

For a few months last spring I kept seeing an ad in all the magazines that showed a small child high in the air dropping toward the upraised arms of a waiting figure below. The image was grainy and distant. I could not

tell if the child was laughing or crying. The copy at the bottom of the page read: "Your father always caught you."

"Look at this," I insisted the first time I saw the ad. "Will you look at this?"

A friend of mine took the magazine, looked at the ad, and then up into my shocked and horrified face.

"They don't mean it that way," she said.

I looked at the ad again. They didn't mean it that way? They meant it innocently? I shuddered. It was supposed to make you feel safe, maybe make you buy insurance or something. It did not make me feel safe. I dreamed about the picture, and it was not a good dream.

I wonder how many other people see that ad the way I do. I wonder how many other people look at the constant images of happy families and make wry faces at most of them. It's as if all the illustrators have television sitcom imaginations. I do not believe in those families. I believe in the exhausted mothers, frightened children, numb and stubborn men. I believe in hard-pressed families, the child huddled in fear with his face hidden, the father and mother confronting each other with their emotions hidden, dispassionate passionate faces, and the unsettling sense of risk in the baby held close to that man's chest. These images make sense to me. They are about the world I know, the stories I tell. When they are accompanied by wry titles or copy that is slightly absurd or unexpected, I grin and know that I will puzzle it out later, sometimes a lot later.

I think that using art to provoke uncertainty is what great writing and inspired images do most brilliantly. Art should provoke more questions than answers and, most of all, should make us think about what we rarely want to think about at all. Sitting down to write a novel, I refuse to consider if my work is seen as difficult or inappropriate or provocative. I choose my subjects to force the congregation to look at what they try so stubbornly to pretend is not happening at all, deliberately combining the horribly serious with the absurd or funny, because I know that if I am to reach my audience I must first seduce their attention and draw them into the world of my imagination. I know that I have to lay out my stories, my difficult people, each story layering on top of the one before it with care and craft, until my audience sees something they had not expected.

Frailty—stubborn, human frailty—that is what I work to showcase. The wonder and astonishment of the despised and ignored, that is what I hope to find in art and in the books I write—my secret self, my vulnerable and embattled heart, the child I was and the woman I have become, not Jesus at the Jordan but a woman with only her stubborn memories and passionate convictions to redeem her.

"You write such mean stories," a friend once told me. "Raped girls, brutal fathers, faithless mothers, and untrustworthy lovers—meaner than the world really is, don't you think?"

I just looked at her. Meaner than the world really is? No. I thought about showing her the box under my desk where I keep my clippings. Newspaper stories and black-and-white images—the woman who drowned her children, the man who shot first the babies in her arms and then his wife, the teenage boys who led the three-year-old away along the train track, the homeless family recovering from frostbite with their eyes glazed and indifferent while the doctor scowled over their shoulders. The world is meaner than we admit, larger and more astonishing. Strength appears in the most desperate figures, tragedy when we have no reason to expect it. Yes, some of my stories are fearful, but not as cruel as what I see in the world. I believe in redemption, just as I believe in the nobility of the despised, the dignity of the outcast, the intrinsic honor among misfits, pariahs, and queers. Artists—those of us who stand outside the city gates and look back at a society that tries to ignore us—we have an angle of vision denied to whole sectors of the sheltered and indifferent population within. It is our curse and our prize, and for everyone who will tell us our work is mean or fearful or unreal, there is another who will embrace us and say with tears in their eyes how wonderful it is to finally feel as if someone else has seen their truth and shown it in some part as it should be known.

"My story," they say. "You told my story. That is me, mine, us." And it is.

We are not the same. We are a nation of nations. Regions, social classes, economic circumstances, ethical systems, and political convictions—all separate us even as we pretend they do not. Art makes that plain. Those of us who have read the same books, eaten the same kinds of food as chil-

dren, watched the same television shows, and listened to the same music, we believe ourselves part of the same nation—and we are continually startled to discover that our versions of reality do not match. If we were more the same, would we not see the same thing when we look at a painting? But what is it we see when we look at a work of art? What is it we fear will be revealed? The artist waits for us to say. It does not matter that each of us sees something slightly different. Most of us, confronted with the artist's creation, hesitate, stammer, or politely deflect the question of what it means to us. Even those of us from the same background, same region, same general economic and social class, come to "art" uncertain, suspicious, not wanting to embarrass ourselves by revealing what the work provokes in us. In fact, sometimes we are not sure. If we were to reveal what we see in each painting, sculpture, installation, or little book, we would run the risk of exposing our secret selves, what we know and what we fear we do not know, and of course incidentally what it is we truly fear. Art is the Rorschach test for all of us, the projective hologram of our secret lives. Our emotional and intellectual lives are laid bare. Do you like hologram roses? Big, bold, brightly painted canvases? Representational art? Little boxes with tiny figures posed precisely? Do you dare say what it is you like?

For those of us born into poor and working-class families, these are not simple questions. For those of us who grew up hiding what our home life was like, the fear is omnipresent—particularly when that home life was scarred by physical and emotional violence. We know if we say anything about what we see in a work of art we will reveal more about ourselves than the artist. What do you see in this painting, in that one? I see a little girl, terrified, holding together the torn remnants of her clothing. I see a child, looking back at the mother for help and finding none. I see a mother, bruised and exhausted, unable to look up for help, unable to believe anyone in the world will help her. I see a man with his fists raised, hating himself but making those fists tighter all the time. I see a little girl, uncertain and angry, looking down at her own body with hatred and contempt. I see that all the time, even when no one else sees what I see. I know I am not supposed to mention what it is I see. Perhaps no one else is seeing what I see. If they are, I am pretty sure there is some cryptic covenant that requires that we will not say what we see. Even when looking

Dorothy Allison

at an image of a terrified child, we know that to mention why that child might be so frightened would be a breach of social etiquette. The world requires that such children not be mentioned, even when so many of us are looking directly at her.

There seems to be a tacit agreement about what it is not polite to mention, what it is not appropriate to portray. For some of us, that polite behavior is set so deeply we truly do not see what seems outside that tacit agreement. We have lost the imagination for what our real lives have been or continue to be, what happens when we go home and close the door on the outside world. Since so many would like us to never mention anything unsettling anyway, the impulse to be quiet, the impulse to deny and pretend, becomes very strong. But the artist knows all about that impulse. The artist knows that it must be resisted. Art is not meant to be polite, secret, coded, or timid. Art is the sphere in which that impulse to hide and lie is the most dangerous. In art, transgression is holy, revelation a sacrament, and pursuing one's personal truth the only sure validation.

Does it matter if our art is canonized, if we become rich and successful, lauded and admired? Does it make any difference if our pictures become popular, our books made into movies, our creations win awards? What if we are the ones who wind up going from town to town with our notebooks, our dusty boxes of prints or Xeroxed sheets of music, never acknowledged, never paid for our work? As artists, we know how easily we could become a Flannery O'Connor character, reading those journals of criticism and burying our faces in our hands, staggering under the weight of what we see that the world does not. As artists, we also know that neither worldly praise nor critical disdain will ultimately prove the worth of our work.

Some nights I think of that sweating, girlish Jesus above my mother's determined features, those hands outspread to cast benediction on those giggling uncertain boys, me in the congregation struck full of wonder and love and helpless laughter. If no one else ever wept at that image, I did. I wished the artist who painted that image knew how powerfully it touched me, that after all these years his art still lives inside me. If I can wish for anything for my art, that is what I want—to live in some child forever—and if I can demand anything of other artists, it is that they attempt as much.

Alfred Kazin

The Art City Our Fathers Built

A city is a place where a small boy, as he walks through it, may see something that will tell him what he wants to do with his life.

—Louis Kahn

I was once that small boy. From my earliest encounters with its art—art that was to liberate my senses and drive me to become a writer after all the poverty this city of the greatest wealth had inflicted on my frightened immigrant parents—New York possessed for this native son, in the words of Scott Fitzgerald from Minnesota, "all the iridescence of the beginning of the world."

I first walked into the Metropolitan Museum seventy-one years ago, as a boy of eleven, led by my father, an immigrant house painter from darkest Brooklyn who liked his firstborn to accompany him as he timidly looked into the city's public places—the Met, the Brooklyn Museum, the great library on Fifth Avenue, the Aquarium on the Battery, the Staten Island ferry when it charged a nickel. In those days one entered the museum from the park. The entrance hall was packed with monumental marble sculptures. I perched myself in one of them, fingering the fragile program of the music that David Mannes's orchestra was playing that night on the balcony. I was staggered by the volume of space around me, the royal look of the great staircase, the plenitude of European splendor. The museum was intoxicatingly full of proud masterpieces I would not see on their home grounds until the war got my generation to London,

Paris, and Rome. The appeal all of this made to my senses was utterly un-expected. And the most astonishing thing was that this first revelation of Europe in all its wonder was taking place in my own city, New York.

When Henry James, a native New Yorker, returned from decades in England to gather impressions for his haughty but irresistible book *The American Scene*, his observations were set against the New York he had known as a boy. He tried to be ironic about the wealth that had built the museum. But he was impressed by the ability of the robber barons to buy art casually and then to give it to the public with an air of benevolence. He wrote:

> *It is a palace of art, truly, that sits there on the edge of the Park, rearing itself with a radiance, yet offering you expanses to tread; but I found it invited me to a matter of much more interest than any mere judging of its dispositions. . . . Education, clearly, was about to seat herself in these marble halls—admirably prepared for her, to all appearance—and is-sue her instructions without regard to cost. . . . There was money in the air, ever so much money—that was, grossly expressed, the sense of the whole intimation. And the money was to be all for the most exquisite things—for all the most exquisite except creation . . . ; for art, selection, criticism, for knowledge, piety, taste. . . . The thought of the acres of can-vas and the tons of marble to be turned out into the cold world . . . ought to have drawn tears from the eyes. But . . . the Museum, in short, was going to be great.*

Once our school made an excursion to the Met. That morning they walked us across the park to the museum, and after entering through the back door I was flung spinning in a bewilderment of delight from the Greek discus throwers to the Egyptian mummies to the rows of knights in armor to the breasts of Venus.

That bewilderment was soon replaced by much-needed information about my own, my native land. We were led up a flight of white steps to a long, narrow room lined with grandfather clocks and portraits of pros-perous Puritan merchants and rosy-faced divines in clerical neckbands, who looked down at me snootily. Nothing for me there. But in the very

back of the museum, in an alcove near the freight elevator, hung so low and lit so dimly that I had to crouch to take them in, were paintings of New York during the period after the Civil War—skaters on the frozen lake in Central Park, red mufflers flying in the wind; a gay crowd moving round and round Union Square Park; horsecars charging between the brownstones of lower Fifth Avenue at dusk.

I had not yet read Whitman and Hart Crane, the poets who most loved New York, and I could only blink in awe at the beauty of the towers of the Brooklyn Bridge as the trolley rumbled across, carrying my father and me to lower Manhattan, where he met nostalgically with his fellow immigrants from Minsk every Saturday night. But here in the museum I could not believe my eyes. Room upon room contained not only Rembrandt and Goya but my city, my country—Winslow Homer's dark oblong of Union soldiers making camp in the rain, tenting tonight, tenting on the old campground, as I had never thought I would see them when we sang that song in school; Thomas Eakins's solitary sculler on the Schuylkill, resting to have his portrait painted in the yellow light, with bright patches of a raw Pennsylvania spring showing on the riverbank; and, most touching to me then, John Sloan's painting of a woman standing in the stern of a New York ferryboat—painted just about the year my parents met.

I regularly left my home across the East River in Brooklyn to throw myself on the city for my education. Every Sunday, I walked from my home in Brownsville straight up Eastern Parkway to the Brooklyn Museum and the Botanic Garden. I did not yet know that Brooklyn's great tree-lined promenades, Eastern Parkway and Ocean Parkway, had been conceived by Frederick Law Olmsted, the visionary in urban landscape who had created Central Park. Nor did I know that he considered his masterpiece to be Brooklyn's Prospect Park, where he had more room to turn the gritty long wasteland into lakes and rambles and proliferating greenery.

I loved walking Eastern Parkway when it was still fresh. Each tree along the path held a plaque commemorating an American soldier fallen in the Great War. To come upon the Brooklyn Museum was a shock, it tried so hard to look grand. Ancient and classical figures with great gaps

Alfred Kazin

between them confronted Eastern Parkway from a ledge below the cornice. Unlike the Met, the museum seemed emptily monumental, too big for its actual holdings. But it was there that I discovered the dusky frail little sea paintings of Albert Pinkham Ryder. Ryder had fled his native New Bedford to paint in New York. Even in the commercial city, his dream life as a painter of the sea startlingly resembled that of Melville, the New Yorker who had embarked from New Bedford for the great whaling voyage that led to *Moby-Dick*.

The Brooklyn Museum also contained the watercolors that John Singer Sargent had brought back from the West Indies. Scintillating as these were, nothing reached me so deeply as the Ryders. Like Eakins and Homer, Ryder was one of those isolate American originals in the closing decades of the nineteenth century who was not so much an influence on the moderns to come as an example of great individual vision and stubborn integrity in the face of neglect. It took Marsden Hartley, that wonderful painter from Maine who was first recognized by Alfred Stieglitz in this country after being admired in Germany, to describe the joy he felt on first seeing a Ryder seascape: "It had in it everything that I knew and had experienced about my own New England ... [and] bore such a force of nature itself as to leave me breathless." I must confess that my own approach to Ryder was more literary. I was fascinated by everything lonely and deep in the old American imagination—Thoreau, Melville, Emily Dickinson. Ryder was of their company.

After I discovered Ryder in the Brooklyn Museum, everything I learned of him I owed to Lewis Mumford. Of all the father figures who guided New York's taste from the twenties on, Mumford was my favorite. He was the American Ruskin, a furious social idealist who linked all the arts. *The Brown Decades*, Mumford's study of the arts in America from 1865 to 1895, recreated not only Ryder but also the other major characters of those prodigious thirty years during which the rough materials of the new industrial world found talents who knew just what to do with them. Louis Sullivan modernized Chicago, Charles Peirce conceived pragmatism, Josiah Gibbs laid out new paths in physical science, Thomas Eakins revealed (to his cost) what a brave artist could make of the unclothed body, male and female alike. The German immigrant John Au-

gust Roebling invented wire rope, making possible suspension bridges, the greatest of which—Brooklyn Bridge—was one of the first works of modern engineering to display itself as a work of art. As Mumford put it:

> The stone plays against the steel: the granite mass in compression, the spidery steel in tension. In this structure, the architecture of the past, massive and protective, meets the architecture of the future, light, aerial, open to sunlight, an architecture of voids rather than solids.

With what grace and loving insight did Mumford pay homage to these original talents!

New York was my connection to everything new and wondrous in the arts. New York was *it*, precisely because it absorbed the foreign as its own, just as the great towers of Brooklyn Bridge reflected the cathedral doors of John Roebling's native town of Mühlhausen, in Germany. The critic Paul Rosenfeld had the perfect title for the book he wrote in the twenties on modern American painters: *Port of New York*. Through the port came the Stieglitz family, whose most famous representative liked to boast, "I am American born, I live in Hoboken." Through the port, at one time or another, because of one war or another, came Marcel Duchamp, Willem de Kooning, Arshile Gorky, Piet Mondrian, André Kertész, André Breton, Max Ernst, Saul Steinberg, Marc Chagall, Mark Rothko, George Grosz, Hans Hofmann, Raphael and Moses Soyer, Meyer Schapiro, Max Weber, Abraham Walkowitz; the fathers of Jacob Epstein, Barnett Newman, Adolph Gottlieb, Franz Kline, Clement Greenberg, Leonard Baskin; the forebears of Helen Frankenthaler.

Hitler was to provoke an emigration of European artists to New York that has been called the largest major artistic migration since the fall of Constantinople. World city, imperial city, city of so many million transplantings seeking the tree of liberty so repeatedly cut down elsewhere! As Yehudi Menuhin said during the Second World War, one of the great war aims was just to get to New York. If the English Revolution was achieved in America, one of the hopes of the French Revolution was realized in New York's art world—careers open to talent, open even to those who just loved art as part of the Creation. How moving it is just to list some of the artists who fled Hitler for America and, without necessarily

Alfred Kazin

settling in New York, helped to make 57th Street, during and after the war, the international art center no single European city had ever been: Salvador Dalí, Fernand Léger, Yves Tanguy, Josef Albers, Jacques Lipchitz, John Hartfield, Wassily Kandinsky, Oskar Kokoschka, Kurt Schwitters, André Masson, Matta Echaurren, Walter Gropius, Marcel Breuer, Lyonel Feininger, Lászlo Moholy-Nagy, Max Beckmann, Mies van der Rohe. When Peggy Guggenheim's Art of This Century gallery opened in October 1942, the design by the Viennese refugee Frederick Kiesler—featuring turquoise floors and paintings suspended from sawed-off baseball bats—provoked the stunned critic for the *New York Sun* to write, "Frankly, my eyes never bulged further from their sockets." When it came to the art world, Delmore Schwartz had it exactly right: "Europe is still the biggest thing in North America."

For American artists in the first half of the century, New York itself was the great new subject. New York painters seemed to love the city more than New York writers did; the painters were tuned in to the passing show, where Stephen Crane, Theodore Dreiser, and later embittered left-wing realists like Michael Gold saw only victims and oppressors. I had no positive city images until I discovered them in art museums. At the old Whitney on Eighth Street, I found Reginald Marsh's paintings of Fourteenth Street shoppers; at the Met, I found John Sloan's neighborly Greenwich Village backyards with prowling cats and laundry drying on the line, and his full-figured secretaries in red hats just released from the office and rollicking under the curve that the Sixth Avenue El made at Thirtieth Street.

There was a certain haste to the painters whom the officially approved artists at the National Academy of Design derogatively called the Ashcan School. This reflected the timely discovery of New York as a subject. Many of the Ashcan paintings were humanly generous but broad in conception, too easy to take. George Bellows's 1924 painting of Dempsey knocking Firpo out of the ring was as pleasant in its way as the Raphael Soyer paintings of meltingly lovable girls sitting around an employment agency. New York realists were more at home with sweating muscles than with the puzzle of existence. But I was glad that Henri, Glackens, Bellows, Luks, and Sloan were around—they gave color, the vibrant smack of life, to a New York that needed the recognition through art that

writers and painters both withheld until the new century burst upon them.

The exception to these too-easily-understood painters of New York scenes was Edward Hopper. Hopper was a man apart. He painted himself in the lonely figures who stared at—never through—the window glass in paintings like *Nighthawks* and *New York Office*. Their indecipherable faces were secondary to the sense of place that imprisoned them. There was no essential difference in Hopper's style or interest from 1924, when he was "recognized," to his death in the late 1960s. He had no interest in "ideas," that bane of performance artists who have unhappily never heard of Wittgenstein's suggestion: "Don't think, *look!*" What absorbed Hopper was certain recurring images—a single figure in a bare room, restaurant, or theater; the shock of Cape Cod light on white shingle boards; bridges and roofs without any figure in the picture to recall the invisible observer who brooded over the thickness and hardness of the building materials.

Early Sunday Morning, which Hopper painted in 1930, has haunted me as no other New York painting ever has. Hopper brought to the silent street—the barber pole, the fire hydrant, the uneven line of window shades, the awnings over the shop fronts—the intensity of his own perception. Every time I come back to it, *Early Sunday Morning* seems larger than I remembered it. Since nothing is so typical of New York as the certain disappearance of something we once loved, the doggedness of Hopper's attachment had to be painted large. Why does that row of low brick houses on lower Seventh Avenue rivet me? It is because the street has entered into Hopper's consciousness in a way that transcends realism. He has made the drab and the commonplace beautiful through the force of belonging. Every detail in the street belongs to us and we to it.

In its artistic beginnings and its social idealism, the unfolding of the century's early years in New York was sweet. "The fiddles are tuning as it were all over America," said the painter John Butler Yeats in 1912. He had settled in New York, explaining that Ireland had become too small to hold him and his son the poet. In John Sloan's painting of a convivial group at the Petitpas' boardinghouse on Twenty-ninth Street, you can see the bearded Yeats benevolently sitting alongside Van Wyck Brooks and

Alfred Kazin

Sloan himself. Painters and writers in those days were part of the same revolution.

In Greenwich Village, John Reed, Mabel Dodge, Randolph Bourne, and Van Wyck Brooks were thinking revolution. At 291 Fifth Avenue, Alfred Stieglitz was showing Matisse, Cézanne, and Picasso—sometimes even before they were shown in Paris. New names were coming to the fore—Stuart Davis and Arthur B. Davies, Marsden Hartley and Georgia O'Keeffe, John Marin and Arthur Dove—many of them linked to Stieglitz, who was not only a genius as a photographer and our first great original in the field, but also a genius as a promoter of American artists.

I met Stieglitz for the first time in 1943 at An American Place, the gallery at Madison and 52nd that he had founded in 1929 after his first two galleries had closed. Although he was near eighty, complained of a weak heart, and had put away his camera because, as he said, "the excitement would kill me," he perked up when he took in the very striking girl I had brought along. "You're a beauty," he grumbled at her from his couch at the back of the gallery. He was vividly the angry old man I had so often read about, irritable in the extreme. In his cracked voice, he railed against the Metropolitan Museum, a place he liked to call the enemy of modern art. Did he know that after his death, his widow, Georgia O'Keeffe, would donate some of his finest works to the Met?

I had become a slave to Stieglitz's eye the moment the writer Gerald Sykes gave me an early print of *The Steerage*, now in the permanent collection of the International Center of Photography in New York. *The Steerage* shows a boatload of immigrants standing on the upper and lower decks of a liner in mid-ocean. I did not know then that the figures in the photograph were on their way *back* to Europe, probably rejected at Ellis Island. Stieglitz, coming on the scene as he left his first-class cabin, had rushed back for his camera—and when he returned, the figures had not moved.

I imagined my mother as the woman who stands on a lower level draped in a towel, facing away. My mother seemed to be frozen forever on that lower deck. The marvel of the composition is how Stieglitz positions the whole scene around the little white bridge with drooping rails that leads the steerage passengers not out of the steerage but only from one level of it to another. What this great artist can do once he seizes the organizing center around which the passengers stand idly brooding! They are

free to go from one level to another, but they are not free of the ship's funnel that hangs over their heads. And all this is seen in a flash from first class, where Stieglitz is looking *down* in every sense. No division of classes, no picture. Yet every structure belonging to the ship itself creates the levels on which the passengers are draped. Stieglitz's approach is entirely aesthetic.

Dorothy Norman was Stieglitz's disciple and biographer, a gifted photographer herself, but so modest in deference to the master that her own beautiful photographs were constricted, almost tiny. She handsomely published a journal called *Twice a Year* (although it came out whenever Dorothy thought of it) and in one issue included reproductions of Stieglitz's most famous photographs. I have been living with them for over half a century. Stieglitz's photographs of old New York possessed my soul. His was the New York through which my mother and father had stumbled to meet as lonely young immigrants.

Stieglitz's genius for composition brought out the beauty of muddy, dirty, snow-encrusted New York at the turn of the century with the special feeling for ensemble that made history in *The Steerage*. In *The Terminal*, a horsecar at the end of the route is being turned around for the trip back. The driver wears a black coat and a large official pumpkin of a hat, white with snow all around the brim. He stands with his back to us as he unbuckles the horse leading his team. The snow and the horses' breath steam up like a layer of white air into the center of the picture. The horsecar has HARLEM written in big letters up front. There are more fresh horses off on one side, blanketed against the cold. On the other side, some gent in a derby is walking through snow past a shop with a sign above the awning, the end of which reads "& Bats." End of the line. The curve of the horsecar on its tracks, the curve in the team of horses tamely standing in the white powdery winter air! This is the winter city in miniature. Stieglitz has not missed a thing. And neither will we, once we grasp the full beauty of his intention.

All this was before the New York art scene was shaken up by the 1913 show at the 69th Regiment Armory, where Marcel Duchamp's nude descended the staircase in cubes. "Before it, a painting truly modern was a rumor," the theater designer Lee Simonson wrote later in the *Seven Arts*. Thanks to its main organizer, the painter Arthur B. Davies, the Armory

Show presented for the first time a comprehensive collection of innovative European work. "International Exhibition of Modern Art" was the official title. Some thirteen hundred exhibits were included, two-thirds of which were American, but it was the European artists who brought the big crowds and aroused so much controversy that when the show reached Chicago, art students wanted to hang Matisse and Brancusi in effigy. The Post-Impressionists alone were represented by eighteen van Goghs, fourteen Cézannes, and thirteen Gauguins. The Fauves, with Matisse at their head, had more than forty pictures. In the first three showings alone, some three hundred thousand visitors paid to enter the Armory.

The Armory Show established a respect for the modern that has survived the many cheap and ridiculous things since done in its name. Royal Cortissoz, for decades the standpat critic of the *New York Tribune* and then the *Herald-Tribune*, growled against "Ellis Island art." But the great Europeans at the Armory Show never saw America, and Duchamp, for all the outrage caused by *Nude Descending a Staircase*, was interested not so much in the work of art as in the idea behind it. His early overriding ambition, says Calvin Tomkins in his amusing account of the art revolution Duchamp fostered, was "to invent a new means of expression that had nothing to do with Cubist theories of what he called 'retinal' art—art whose appeal was mainly or exclusively to the eye rather than to the mind." The art world was soon too rich in ideas, though few were as arrestingly impudent and brilliant as Duchamp's, whose great passion was not art but chess, with its endless strategies for knocking out your opponent.

Two years after the Armory Show, Duchamp rolled into New York to find himself already famous. He had said to Walter Pach of the famous Pach photography family, "I do not go to New York, I leave Paris." But New York soon became his favorite city, the place, Tomkins reports, where he felt more at home than anywhere else. Duchamp was delighted with America because he thought it a one-class country, called Greenwich Village a real Bohemia full of people doing absolutely nothing, and considered New York itself "a complete . . . work of art." The city ignored the cultural past and was therefore "a perfect terrain for new developments."

While subsisting on the two dollars an hour he got for French lessons, Duchamp made the West Sixty-seventh Street duplex owned by the collector Walter Arensberg and his wife Louise the site of the most brilliant circle in New York. In those heady days early in the new century, when it wasn't just fun to talk of turning the world upside down but positively a social duty, Duchamp promoted art as a mental act. "It was always the idea that came first, not the visual example," he said.

This was Duchamp's real but insidious contribution to the ever more fashionable art scene, for nothing is so easy for an artist to obtain as an idea that calls on the viewer to complete it when it takes form. And even when it doesn't. William Blake said that "the eye sees more than the heart knows." Art for Duchamp was not the historic struggle of the painter to learn all that his eye has seen but that is still buried in his consciousness. It was a thought, a whim, a prank, when, in 1917, he submitted a urinal under the title *Fountain*, and signed "R. MUTT," to an exhibition of the Society of Independent Artists, and announced that common manufactured items, "readymades," were works of art by virtue of having been chosen and signed.

After he met Duchamp and his circle, William Carlos Williams wrote admiringly, "There had been a break somewhere, we were streaming through, each thinking his own thoughts, driving his own designs toward his self's objectives." Yet Williams's central directive to poets was "no ideas but in things." He was to hate T. S. Eliot's *The Waste Land* because it was such a reactionary *concept* of the modern world, without faith, gone to hell. How to reconcile Williams's belief in things over ideas? Everything before the war was challenging if it was really new.

The modern was eventually sanctified when it was institutionalized in 1929 as the Museum of Modern Art. Lincoln Kirstein, who was long a member of its Advisory Committee and a friend of its founding director, Alfred Barr, broke with the museum in a 1946 article called "The State of Modern Painting." Kirstein complained of "the general acceptance and canonization of abstract painting—a modern Abstract Academy that, like its academic predecessors, now wins prizes in eminently respectable salons." He was in no sense opposed to "the use of unhampered imagination, experiment in new method or material, or what is loosely called dis-

tortion." But he was opposed to "improvisation as method, deformation as a formula, and painting (which is a serious matter) as an amusement manipulated by interior decorators and high-pressure salesmen." The useful catalogues put out by the Museum had done their job almost too well. "Today," wrote Kirstein, "young painters feel that the past fifty years or more are more instructive and worthy of imitation than the past five hundred years."

At his death in 1996, it was remembered of Kirstein that he thought modern art was drifting toward a dangerous, self-canceling solipsism. The art world was certainly getting jammed with theoreticians—many of whom resembled critics who found it easier to interpret art than to paint it. Joan Acocella reminded us that Kirstein wanted to restore to painting "the great tradition stretching from Giotto to the nineteenth century."

The pleasure I get from contemporary art is not an illusion. But on the margins of inspiration, a lot of it has become just publicity seeking: putting plates on the canvas instead of the table; painting with one's own hair instead of a brush; publicly bathing in streams of foam; "performing" a work of art instead of creating one; and, in general, as the art critic Harold Rosenberg declaimed of something called Action Painting when that was the latest, aiming "to fuck up the canvas." Big deal!

Still, Nietzsche said it all: "We have Art so that we may not perish of the truth." Art makes up for a lot in life. It is the great redeemer, the transformer, the recurrent magic whose secrets are never fully known even to those who create it. When art begins in pleasure and gives us pleasure, as it has for me in New York City, we come close to loving the world as we never did before.

Mary Gordon

Still Life

Notes on Pierre Bonnard and My Mother's Ninetieth Birthday

In the year 1908, Pierre Bonnard painted *The Bathroom* and my mother was born. The posture of the young woman in the painting is that of someone enraptured by the miracle of light. The light is filtered through the lace curtains, and its patterning is reflected in the water that fills the tub into which she is about to step. Even the floral spread on the divan from which she has just risen is an emblem of prosperity and joy. Bonnard is famous for painting bathing women; in all her life my mother has never taken a bath. At three, she was stricken with polio, and she never had the agility to get in or out of a bathtub. She told me that once, after I was born, my father tried to lift her into a bath, but it made them both too nervous.

Ninety years after the painting of *The Bathroom*, ten days before my mother's ninetieth birthday, I am looking at the works of Bonnard at the Museum of Modern Art, a show I've been waiting for with the excitement of a teenager waiting for a rock concert. I was not brought to museums as a child; going to museums wasn't, as my mother would have said, "the kind of thing we went in for." It is very possible that my mother has never been inside a museum in her life. As a family we were pious, talkative, and fond of stories and the law. Our preference was for the invisible.

I can no longer remember how looking at art became such a source of solace and refreshment for me. Art history wasn't anything I studied formally. I think I must have begun going to museums as a place to meet friends. However and wherever it happened, a fully realized painterly vision that testifies in its fullness to the goodness of life has become for me a repository of faith and hope, two of the three theological virtues I was brought up to believe were at the center of things. It is no accident, I suppose, though at the time I might have said it was, that I've arranged to meet two friends at the Bonnard show at the same time that I'm meant to phone the recreation therapist at my mother's nursing home to plan her birthday party. Fifteen minutes after I arrive, I'll have to leave the show. The therapist will be available only for a specific half hour; after that, she's leaving for vacation.

Am I purposely creating difficulties for myself, a situation of false conflict, so that I can be tested and emerge a hero? There is the chance that I will not be able to leave the dazzle of the first room, to resist the intoxication of these paintings, so absorbing, so saturating, so suggestive of a world of intense color, of prosperous involvement, of the flow of good life and good fortune. There's the chance that I will forget to call the therapist. I do not forget, but my experience of the first paintings is poisoned by the fear that I will.

My mother has no idea that her ninetieth birthday is coming up. She has no notion of the time of day, the day of the week, the season of the year, the year of the century. No notion of the approaching millennium. And no idea, any longer, who I am. Her forgetting of me happened just a few months ago, after I had been traveling for more than a month and hadn't been to see her. When I came back, she asked me if I were her niece. I said no, I was her daughter. "Does that mean I had you?" she asked. I said yes. "Where was I when I had you?" she asked me. I told her she was in a hospital in Far Rockaway, New York. "So much has happened to me in my life," she said. "You can't expect me to remember everything."

My mother has erased me from the book of the living. She is denying the significance of my birth. I do not take this personally. It is impossible for me to believe any longer that anything she says refers to me. As long as I remember this, I can still, sometimes, enjoy her company.

*

The day before I go to the Bonnard show, I visit my mother. It is not a good visit. It is one of her fearful days. I say I'll take her out to the roof garden for some air. She says, "But what if I fall off?" I bring her flowers, which I put in a vase near her bed. She says, "But what if they steal them or yell at me for having them?" She asks me thirty or more times if I know where I'm going as we wait for the elevator. When I say we'll go to the chapel in a little while, she asks if I think she'll get in trouble for going to the chapel outside the normal hours for Mass, and on a day that's not a Sunday or a holy day. She seems to believe me each time when I tell her that she won't fall off the roof, that no one will reprimand her or steal her flowers, that I know where I'm going, that she will not get in trouble for being in church and saying her prayers.

I have brought her a piece of banana cake and some cut-up watermelon. There are only three things to which my mother now responds: prayers, songs, and sweets. Usually, I sing to her as we eat cake and then I take her to the chapel, where we say a decade of the rosary. But today she is too cast down to sing, or pray, or even eat. There is no question of going out onto the roof. She just wants to go back to her room. She complains of being cold, though it is 95 degrees outside and the air conditioning is off. It is not a long visit. I bring her back to her floor after twenty minutes.

On my mother's floor in the nursing home, many people in wheelchairs spend most of their days in the hall. There is a man who is still attractive, though his face is sullen and his eyes are dull. Well, of course, I think, why wouldn't they be? He looks at me, and his dull eyes focus on my breasts in a way that is still predatory, despite his immobility. I take this as a sign of life. It's another thing I don't take personally. In fact, I want to encourage this sign of life. So I walk down the hall in an obviously sexual way. "*Putana!*" he screams out behind me. I believe that I deserve this; even though what I did was an error, a misreading, it was still, I understand now, wrong.

In front of the dayroom door sits a legless woman. Her hair is shoulder length, dyed a reddish color; her lips are painted red. The light blue and white nylon skirts of her dressing gown billow around her seat, and she looks like a doll sitting on a child's dresser or a child's crude drawing of a doll.

My mother was once a beautiful woman, but all her teeth are gone now. Toothless, no woman can be considered beautiful. Whenever I arrive, she is sitting at the table in the common dining room, her head in her hands, rocking. Medication has eased her anxiety, but nothing moves her from her stupor except occasional moments of fear, too deep for medication. This is a room that has no windows, that lets in no light, in which an overlarge TV is constantly blaring, sending images that no one looks at, where the floors are beige tiles, the walls cream-colored at the bottom, papered halfway up with a pattern of nearly invisible grayish leaves. Many of the residents sit staring, slack-jawed, open-mouthed. I find it impossible to imagine what they might be looking at.

It is difficult to meet the eyes of these people; it is difficult to look at their faces. I wonder if Bonnard could do anything with this lightless room. If he could enter it, see in these suffering people, including my mother, especially my mother, only a series of shapes and forms, concentrate on the colors of their clothing (a red sweater here, a blue shirt there), transform the blaring images on the TV screen to a series of vivid rectangles, and, failing to differentiate, insisting on the falseness of distinctions, of an overly rigid individuality, saying that we must get over the idea that the features of the face are the important part—would he be able to create a scene of beauty from this scene, which is, to me, nearly unbearable? He once told friends that he had spent much of his life trying to understand the secret of white. How I envy him such a pure preoccupation, so removed from the inevitable degradations of human character and fate. So he could paint wilting flowers, overripe fruit, and make of them a richer kind of beauty, like the nearly deliquescing purple grapes, the visibly softening bananas, of *Bowl of Fruit*, 1933. "He let the flowers wilt and then he started painting; he said that way they would have more presence," his housekeeper once said.

The people in the dining room are wilting, they are decomposing, but I cannot perceive it as simply another form, simply another subject or observation. I cannot say there are no differences between them and young, healthy people, no greater or lesser beauty, as one could say of buds or wilting flowers, unripe fruit or fruit on the verge of rotting. It is impossible for me to say that what has happened to these people is not a slow disaster.

And how important is it that when we read or look at a painting we do not use our sense of smell? The smells of age and misery hang over the common room. Overcooked food, aging flesh. My mother is kept clean, but when I bend over to kiss her hair, it smells like an old woman's. And there is the residual smell of her incontinence. My mother wears diapers. A residual smell that is unpleasant even in children but in the old is not only a bad smell but a sign of shame, of punishment: a curse. I cannot experience it any other way. My mother's body is inexorably failing, but not fast enough. She is still more among the living than the dying, and I wonder, often, what might be the good of that.

I thought that the women in the Bonnard paintings would all be long dead. As it turns out, at least one is still alive.

It is the day of my mother's birthday. Two of my friends, Gary and Nola, have agreed to be with me for this day. They are both very good-looking people. They are both, in fact, beauties. Gary is a priest; in another age, he might be called my confessor, not that he has heard my confession in the sacramental sense but because he is someone to whom I could tell anything, with no shame. Nola was my prize student, then she worked as my assistant for four years. We are proud that we have transformed ourselves from teacher/student, employer/employee, into, simply, friends.

When I thank him for agreeing to come to my mother's party, Gary says, "This will be fun." "No it won't," I say, "it won't be fun at all." "Well, it will be something to be got through. Which is, in some ways, not so different from fun." "It is," I say, "it is." "No, not really. It isn't really," he says, and we both laugh.

Gary's mother is also in a nursing home, in St. Louis, Missouri, a city I have never visited. She accuses his father, who is devoted to her, who has been devoted for years, of the most flagrant infidelities. All he says in response is, "I didn't do that, I would never do that." When we speak about our mothers, of our mothers' fears and sadnesses, particularly about the shape his mother's rage has taken, Gary and I agree that if we could understand the mystery of sex and the mystery of our mothers' fates we would have penetrated to the heart of something quite essential. We very well know that we will not. This is very different from Bonnard's secret of white.

Gary's father visits his mother in the nursing home every day. The end of Marthe Bonnard's life was marked by a withdrawal into a depressed and increasingly phobic isolation, so that the shape of a large part of her husband's life was determined by her illness, finding places for her to take cures, and staying away from people whom she feared, who she thought were staring at her, laughing at her. In 1931, Bonnard wrote, "For quite some time now I have been living a very secluded life as Marthe has become completely antisocial [*Marthe étant devenue d'une sauvagerie complète*] and I am obliged to avoid all contact with other people. I have hopes though that this state of affairs will change for the better but it is rather painful."

Did this forced isolation, in fact, suit Bonnard very well; was it the excuse he could present to a sympathetic world so that he could have the solitude he needed for his work? What is the nature of the pain of which he spoke? What was the nature of her "*sauvagerie complète*"? In the painting in which he suggests Marthe's isolation, *The Vigil*, although she sits uncomfortably in her chair, in a room empty of people, alienated even from the furniture, unable to take comfort even from her dog, she appears still young, still attractive, still someone we want to look at. In fact, she was fifty-two, and someone whose misery, if we encountered it in person, might have caused us to avert our eyes.

I do not shape my life around my mother's needs or her condition. I try to visit her once a week, but sometimes I don't make it, sometimes it is two weeks, even three. If life is pressing on me, it is easy for me to put the visit off, because I don't know how much it means to her, and I know that she forgets I was there minutes after I have left, that she doesn't feel a difference between three hours and three weeks. If I believed that visiting my mother every day would give something important to my work, as the isolation required by Marthe Bonnard's illness gave something to her husband's, perhaps I would do it. But when I leave my mother, work is impossible for me; the rest of the afternoon is a struggle not to give in to a hopelessness that makes the creation of something made of words seem ridiculous, grotesque, a joke.

Two weeks before my mother's birthday, Gary celebrated the twenty-fifth anniversary of his ordination. His father couldn't be there; he

wouldn't leave Gary's mother, even for a day. That was a grief for Gary, but most of the day was full of joy, a swelling of love, a church full of all the representatives of Gary's life—musicians, artists, dancers, writers, the bodybuilders he came to know at the gym where he works out, to whom he is an informal chaplain, as well as the parishioners he serves. The music was mostly provided by a gospel choir, who brought everyone to tears, and whose music blended perfectly with the parish choir's Gregorian chant, with which it alternated. It was a day of harmony, of perfect blending, but with high spots of color, like the paintings of Bonnard. I bought for the occasion a red silk dress with a fitted waist and an elaborate collar. I wore gold shoes. On the altar, flanked by red and white flowers in brass vases, I read the epistle of St. Paul to the Galatians, which assures that in Christ there is neither male nor female, slave nor free—a blurring of distinctions like the blurring of boundaries in Bonnard, where the edge of an arm melts into a tablecloth, a leg into the ceramic of a tub, flesh into water, the sun's light into the pink triangle of a crotch.

Nola has the long legs, slim hips, and small but feminine breasts of Marthe Bonnard. I know this because a certain part of our relationship centers around water. We swim together in the university pools; afterward we shower and take saunas. She has introduced me to a place where, three or four times a year, we treat ourselves to a day of luxury. A no-frills bath in the old style, a shvitz, a place where we sit in steam, in wet heat, in dry heat, in a room that sounds like something from the *Arabian Nights:* the Radiant Room. We spend hours naked among other naked women, women who walk unself-consciously, women of all ages and all ranges of beauty, in a place where wetness is the rule, where a mist hangs over things, as in the bathrooms of Bonnard. The preponderance of bathing women in Bonnard's work has been explained by Marthe Bonnard's compulsive bathing. She sometimes bathed several times a day. This may have been part of a hygienic treatment connected to her tuberculosis. But whatever the cause, her husband used it triumphantly.

Nola has just come from a friend's wedding in Maine. She was seated at the reception next to a German student, who became besotted with her. He grabbed her head and tried to put his own head on her shoulder. "You must come and have a drink with me at my inn," he said to her. She refused.

"You weren't tempted by all that ardor?" I ask her.

"No," she says. "I saw he had no lightness, that there was no lightness to him or anything that he did."

Bonnard's paintings are full of light, but they are not exactly about lightness, and his touch is not light, except in the sense that the paint is applied thinly and wetly. But he is always present in his paintings, and his hand is always visible.

He has not tried to efface himself; he has not tried to disappear.

When I walk into the dining room on the day of my mother's birthday, I see that she has already been served lunch. The staff has forgotten to hold it back, though I told them a week ago that I would be providing lunch. She hasn't touched anything on her tray except a piece of carrot cake, which she holds in her hands. The icing is smeared on her hands and face. I don't want my friends to see her smeared with icing, so I wet a paper towel and wipe her. This fills me with a terrible tenderness, recalling, as it does, a gesture I have performed for my children. If I can see her as a child, it is easy to feel only tenderness for her. Bonnard paints children most frequently in his earlier period, in the darker Vuillard-like paintings, in which it is his natal family that is invoked. In the brighter pictures, children do not take their place as representatives of the goodness of the world. That place is taken up by dogs. In the painting *Marthe and Her Dog*, Marthe and a dachshund greet each other ecstatically in the foreground. In the far background, faceless, and having no communication with the woman and her dog, children run, leaving lime-colored shadows on the yellow grass.

As I wipe my mother's face, I see that her skin is still beautiful. I hold her chin in my hand and kiss her forehead. I tell her it's her birthday, that she's ninety years old. "How did that happen?" she asks. "I can't understand how that could happen."

I have brought her a bouquet of crimson, yellow, and salmon-pink snapdragons. She likes the flowers very much. She likes the name. "Snapdragons. It seems like an animal that's going to bite me. But it's not an animal, it's a plant. That's a funny thing."

One reason I bought the flowers is that the colors reminded me of Bonnard. I don't tell my mother that. Even if she still had her wits, I would

not have mentioned it. Bonnard is not someone she would have heard of. She had no interest in painting.

I have bought food that I hope will please my mother, and that will be easy for her to eat: orzo salad with little pieces of crayfish cut into it, potato salad, small chunks of marinated tomatoes. I have bought paper plates with a rust-colored background, upon which are painted yellow and gold flowers and blue leaves. I deliberated over the color of the plastic knives, forks, and spoons and settled on dark blue, to match the leaves. I am trying to make an attractive arrangement of food and flowers, but it's not easy against the worn gray formica of the table. I think of Bonnard's beautiful food, which always looks as if it would be warm to the touch. It is most often fruit, fruit that seems to be another vessel of sunlight, as if pressing it to the roof of your mouth would release into your body a pure jet of sun. Bonnard's food is arranged with the generous, voluptuous propriety I associate with the south of France, though Bonnard moved often, dividing his time between the south and the north. He places his food in rooms or gardens that themselves contribute to a sense of colorful plentitude. Yet it is very rare in Bonnard that more than one person is with the food; none of the festal atmosphere of the Impressionists, none of Renoir's expansive party mood, enters the paintings of Bonnard in which food is an important component. The beautiful colors of the food are what is important, not that the food is part of an encounter with people who will eat it, speak of it, enjoy one another's company.

Nola and Gary and I enjoy one another's company; I do not know what my mother enjoys. Certainly, the colorful food—the pink crayfish in the saffron-colored orzo, the red tomatoes, the russet potatoes punctuated with the parsley's severe green—is not a source of joy for her. Joy, if it is in the room, comes from the love of friends, from human communion—usually absent in the paintings of Bonnard. I do not think, though, that my mother feels part of this communion.

I talk about the food a bit to my mother, but she isn't much interested in descriptions of food. She never has been. She always had contempt for people who talked about food, who recounted memorable meals. She doesn't join us in saying the Grace in which Gary leads us. Nor does she join us in singing the songs that, two weeks ago, she still was able to sing: "Sweet Rosie O'Grady," "Daisy Daisy," "When Irish Eyes Are Smiling."

Mary Gordon

Nothing focuses her attention until the cake, a cheesecake, which she picks up in her hands and eats messily, greedily. I wonder if it is only the prospect of eating sweets that keeps my mother alive.

When we are about to leave, I tell my mother that I'm going on vacation, that I won't see her for three weeks, that I am going to the sea. "How will I stand that, how will I stand that?" she says, but I know that a minute after I'm gone she'll forget I was there.

I have bought the catalogue of the exhibition, and when I leave my mother I go home and look at it for quite a long time. I read that Bonnard once said that "he liked to construct a painting around an empty space." A critic named Patrick Heron says that Bonnard knew "how to make a virtue of emptiness." Illustrating Bonnard's affinities with Mallarmé, Sarah Whitfield, the curator of the show, quotes a description of a water lily in one of Mallarmé's prose poems. The lily encloses "in the hollow whiteness a nothing, made of intact dreams, of a happiness which will not take place."

Much of my mother's life is made up of emptiness. She does, literally, nothing most of the day. For many hours she sits with her head in her hands, her eyes closed, rocking. She is not sleeping. I have no idea what she thinks about or if she thinks, if she's making images. Are images the outgrowth of memory? If they are, I don't know how my mother can be making images in her mind, since she has no memory. And, if her eyes are mostly closed, can she be making images of what is in front of her? The beige walls and linoleum, her compatriots with their withered faces, thin hair, toothless mouths, distorted bodies? The nurses and caretakers, perhaps? No, I don't think so. I think that my mother's life is mostly a blank, perhaps an empty screen occasionally impressed upon by shadows.

Sarah Whitfield says that in the center of many of Bonnard's pictures is a hole or a hollow: a tub, a bath, a basket, or a bowl. A hole or hollow that makes a place for a beautiful emptiness. Nola once described her mother's life as having graceful emptiness so that a whole day could be shaped around one action. We both admired that, so different from the frantic buzz that often characterizes our lives. I am afraid that the emptiness at the center of my mother's life is neither beautiful nor graceful but a blankness that has become obdurate, no longer malleable enough even

to contain sadness. An emptiness that, unlike Bonnard's or Mallarmé's or Nola's mother's, really contains nothing. And there is nothing I can do about it. Nothing.

I don't know what that emptiness once contained, if it once held Mallarmé's intact dreams; dreams of happiness, which, for my mother, will not now be realized. Perhaps she is experiencing the "emptying out" of which the mystics speak, an emptying of the self in order to make a place for God. I don't know, since my mother does not use language to describe her mental state. I try to allow for the possibility that within my mother's emptiness there is a richness beyond language and beyond visual expression, a truth so profound that my mother is kept alive by it, and that she lives for it. To believe that, I must reject all the evidence of my senses, all the ways of knowing the world represented by the paintings of Bonnard.

Bonnard's mistress, Renée Monchaty, killed herself. There are many stories that surround the suicide. One is that she killed herself in the bath, a punitive homage to her lover's iconography. Another is that she took pills and covered herself with a blanket of lilacs. I also have heard that Marthe, after the painter finally married her, insisted that Bonnard destroy all the paintings he had done of Renée. I don't know if any of these stories is true, and I no longer remember where I heard them.

In one painting that survives, *Young Women in the Garden*, Renée is suffused in a yellow light that seems like a shower of undiluted sun; her blonde hair, the bowl of fruit, the undefined yet suggestively fecund floral background, are all saturated with a yellowness, the distilled essence of youthful hope. Renée sits, her head resting against one hand, a half smile on her face, her light eyes catlike and ambiguous; she sits in a light-filled universe, in front of a table with a striped cloth, a bowl of apples, a dish of pears. In the margins, seen from the rear and only in profile, Marthe peers, eclipsed but omnipresent. I am thinking of this painting as I stand in the corner of the dining room, watching my mother from the side, like Marthe, the future wife. How can it be, I wonder, that Renée—who inhabited a world of yellow light, striped tablecloths, red and russet-colored fruit, a world in which all that is good about the physical presented itself in abundance—chose to end her life? While these old people, sitting in a windowless room with nothing to look at but the hysteri-

Mary Gordon

cally colored TV screen, their bodies failing, aching, how can it be that they are fighting so desperately for the very life that this woman, enveloped in such a varied richness, threw away? I am angry at Renée; she seems ungrateful. At the same time I do not understand why these people whom my mother sits among do not allow themselves to die. Renée had so much to live for, to live in, and chose not to live. What do they have to live for? I often ask myself of my mother and her companions. And yet they choose, with a terrible animal avidity, to continue to live.

In a 1941 letter to Bonnard, Matisse writes that "we must bless the luck that has allowed us, who are still here, to come this far. Rodin once said that a combination of extraordinary circumstances was needed for a man to live to seventy and to pursue with passion what he loves." And yet the last self-portraits painted by Bonnard in his seventies are as desolate as the monologues of Samuel Beckett. *Self-Portrait in the Bathroom Mirror* portrays a nearly featureless face, eyes that are more like sockets, a head that seems shamed by its own baldness, the defeatist's sloping shoulders, arms cut off before we can see hands. In the *Self-Portrait* of 1945, Bonnard's mouth is half open in a gesture of desolation; his eyes, miserable, are black holes, swallowing, rather than reflecting, light. At the end of his life, Bonnard was deeply dejected by the loss of Marthe, of his friends, by the hardship of the war, which he includes in one of his self-portraits by the presence of a blackout shade. Is it possible that, despite his portrayal of the joy and richness of the colors of this world, despite his mastery and his absorption in the process of seeing, despite his recognition and success, his last days were no more enviable than my mother's?

Wendy Ewald

Portraits and Dreams: Photographs and Stories by Children of the Appalachians

In the communities of Appalachia, where few extra material comforts exist, photographs are startlingly prominent on the walls in people's homes and in family albums tucked away in living-room drawers: photographs of schoolchildren with brushed hair and buttoned collars; young men in army uniforms; families grouped around the casket of a relative or a friend; photographs telling the stories of the families who live there, binding the generations and preserving the past.

Perhaps it is this familiarity with photographs that explains why the photographs made by children I taught in Kentucky are so extraordinary. The children were already keen observers. Their parents taught them respect for and fear of their surroundings. They watch the crops grow, the seasons change, the animals being born and slaughtered, and when the boys go hunting they sit quietly watching and listening for signs of nearby animals. Their photographs speak from within their lives and record moments that suggest rhythms of everyday life. The world they present is small and intimate, but their perception of it is detailed, accepting and complex.

Although much has changed during the last generation, life on Cowan and Kingdom Come creeks and Campbells Branch is still inti-

mate, quiet and strongly independent. Ties to the land, families and community are closely held, rooted in a cultural past and bound to nature's rhythms of birth, growth and decay. Most families tend gardens and keep a few animals. Coal mining is just about the only outside employment. Each town has a post office that is also a general store, a church and a school.

I arrived in Kentucky in February of 1975. I was twenty-four and just out of college. I rented a small house on Ingram's Creek, one of the most remote and beautiful hollers in Letcher County. I wanted to make a document of my new community that had the soul and rhythm of the place, but the camera seemed to get in the way. I also wanted to get to know the people, and the one thing I could offer them was to teach their children to take pictures, so after a month of settling in and meeting my neighbors I decided again to teach students in the local elementary schools. I had heard that the principal of Cowan Elementary School, Mr. Gatton, might be receptive to my idea. I went to his office one day in March and left a message with the secretary. Within half an hour he had tracked me down and was ready to begin. A grant from the Polaroid Foundation provided us with cameras and film. That April I taught a class for the fifth, sixth, seventh and eighth graders at Cowan and in May for all the students at the Kingdom Come School. Because of the success of this small project, the next year the Kentucky Arts Commission gave us darkroom equipment and a grant for supplies.

During the next school year, 1975–76, I taught in three schools. We built darkrooms at the two larger ones—Campbells Branch and Cowan. At Cowan all that was available was the boiler room. The furnace was fired by coal and when it kicked on I had to yell to be heard over the roar. We ran hoses along the floor from the water tanks to mix chemicals and wash negatives, but sometimes they broke and the coal dust and water mixed together to leave a layer of gray sludge on the floor. We put our four new enlargers and the stabilizer that develops, fixes and spits out a dry print in ten seconds in the janitor's closet. Half of the students could print in the closet while the other half developed negatives in changing bags in the boiler room.

Once we had built the darkroom we began using Instamatic cameras, which gave us negatives. Each student bought a ten-dollar camera from me; I hoped that by buying the camera he would value it as something he had worked for and would have as long as he took care of it. If he didn't have the money, he earned it by mowing lawns, or holding a bake sale or a raffle. I supplied the students with film and flash.

Like any artists, they were inspired sometimes more than others. They needed to have their cameras with them always and plenty of film, so that when they wanted to photograph something—a hog killing, a colt being born, a birthday party—they could. For the best of them picture taking became, simply, part of their lives and especially of their play. Kingdom Come was one of the last one-room schools in Kentucky. It survived consolidation because the buses couldn't bring children down the road out of the holler to school. The road in a few spots is actually the creek. The school building was a white wooden house on the land that had been given to the county a hundred years ago by the Ison family. Before the roads were built and cars were available the school had maybe a hundred students. When I arrived there were only seventeen. Inside were two big rooms, the kitchen and schoolroom. Every morning during the cold months the students took turns bringing in coal from the coal pile next to the creek to fill the potbellied stove that heated the school. They studied together in small groups: Freddy Childers and Billy Dean Ison in the first grade and Shirley Couch in the second grade, Amy Cornett, Mary Joe Cornett and Tammy Williams in the third and fourth grades. The older children helped the younger ones.

The first day, I gave out the Polaroid cameras and showed them how to set the distance, to push the shutter without moving the camera, how to pull the film out and coat the picture. Each student took one photograph while the rest of us watched to catch his mistakes. Freddy was by far the smallest, shortest kid in the school and the most energetic. He took his first picture of Billy Dean, who was at least a head taller. He didn't understand that he had to change the angle of the camera in order to include what was above or below his eye level, so Billy Dean's head was cut off. The other students made fun of Freddy but then explained

Wendy Ewald

that only what was inside the white line painted in the viewfinder appeared in the photograph. He caught on, and the first time he took the camera home brought back two self-portraits: "Me and my brother Homer" and "Self-portrait with the picture of my biggest brother, Everett, who killed himself when he came back from Vietnam." In his portrait Freddy holds a picture of Everett when he was a boy. Everett had been the favorite son. One day after he came home from Vietnam he put on his army uniform, turned on the radio, and shot himself through the heart. Homer is Freddy's retarded brother. His speech is slurred but Freddy understands him and takes care of him as if he were his little brother. Freddy kept Homer in cigarettes, which he had a habit of eating, and made sure he didn't wander off. He never thought to be ashamed of Homer.

Bonnie and Luke Capps are twins. Bonnie was in the fifth grade and Luke in the fourth. They both loved to photograph their flaxen-haired half-sisters playing in the mud or on their bikes in the afternoon. Mary Joe Cornett was a shy girl in the fourth grade who didn't hesitate to direct her subjects with authority. The photographs of her family are carefully staged portraits at mealtime, in the barn or in front of old family portraits.

In the autumn of 1977 I taught the fourth-grade class at Campbells Branch. I had been warned by their teacher that these children had the lowest IQs of any in the school. As it turned out, they were the most talented group I worked with. The first day, their teacher sent them to me single-file. Billy Jean Ison, Robert Dean Smith, Maywood Campbell, Ruby Cornett and Greg Cornett. I realized that except for Denise Dixon and Myra Campbell, who were extremely skinny, all were short and fat. Their teacher had also warned me that they were rowdy, but I found them to be so well behaved that I wondered whether we could relax enough to work together. Once they took the cameras home and developed their first roll of film, they were so excited they forgot the rules of formal classroom behavior. Instead of taking their seats and waiting for instructions as they did in their regular classes, they began to work right away on their own. Some would help me set up—sweep the floor, clean the drying cabinet. Ruby, Denise and sometimes Johnny Wilder mixed the developer, while

the other students developed film or began printing. Now in order to get their attention I had to call a group meeting. They were independent and passionate workers.

Darlene Dixon, a teacher's aide, watched over the darkroom, and I stayed outside to look at the contact sheets and prints. Every semester after a conversation with each student about what he liked taking pictures of and what his problems were I made suggestions about what he might try next. I noticed that Maywood Campbell's pictures were always slightly disappointing to her. I looked at her negatives. She had chosen to photograph very intimate family moments, but her compositions were a bit off. In one photograph her little brother was riding on her grandfather's shoulders. Their outstretched left arms were cut off. She had tried to center her compositions, so they fell apart when she didn't succeed. I advised her to walk around and just look through the camera for a few days to become more aware of the edges of the frame.

I wanted to create a lively, open atmosphere in the classroom so the students felt at home expressing themselves. There were materials for drawing, writing and making books, and there were always photography books. The pictures were starting points for all sorts of conversations. Allen Shepherd and Robert Dean picked up a book of photographs of World War II. Their reactions drew the others. "Man, look at these." We sat on the floor around the book and I asked them to tell me what was happening in the pictures. When they looked at a photograph of Hitler, I asked if they knew who he was. "A baseball player," Allen guessed. I was startled that they had never learned who Hitler was, so I told them what I knew about Hitler's role in the war. Then we looked at the picture again. I suggested that what we know about the subject of a photograph changes our interpretation of it, but it should contain clues that point us in the right direction.

I also brought in books made by other children, some of them diaries published when their authors were adults. *Opal* is one begun by a country girl when she was five. It describes her fantasy world in the country. We took turns reading it out loud, and Billy Jean and Allen literally fell off their seats laughing about the "cathedral service" Opal held for her pig Aphrodite. Reading Opal's stories gave them the idea that other children

Wendy Ewald

could enjoy their pictures just as much as they had Opal's stories. Her diary encouraged some of them to write. Robert Dean kept a diary for a year. For the first month I could not read a thing he had written. There were no spaces between the words and he had spelled everything phonetically. When I deciphered it, I found that he had written beautiful passages each day about what he had done, what his hounds had tracked or how the corn field looked in the afternoon.

Persuading them to see the eloquence of their rough photographs was more difficult. There were no books of children's photographs to look at. They hadn't seen anything like the photographs they were going to take in subject matter, tonal range or surface. The portraits they admired were the portraits of Hank Williams and Dolly Parton on their album covers and the landscape pictures of fields of flowers in the seed catalogues, but they were able to give each other encouragement. Almost every day they put up their pictures for a discussion. I guided each one to tell us what he was trying to say with his pictures and the others to tell him what feelings the pictures evoked for them. In that way they could learn to communicate first with each other. Later, when they had exhibitions in the school, in the town bank, at the University of Kentucky and finally in galleries in New York and Chicago, they could see the value of their photographs in other contexts.

As they became more comfortable with the camera, I wanted them to expand their ideas about picture making but to stay close to what they felt deeply. I asked them to photograph themselves, their families, their animals, their community, stories they could tell with pictures and finally their dreams or fantasies. When they made self-portraits they learned that they could be the subjects of their own photographs and create characters for themselves. The assignment to photograph their dreams brought into play their imaginary world. Before they began, to establish a receptive audience for their very personal and often frightening fantasies, we closed ourselves in the darkroom, sat on the floor and told each other our scariest dreams. The photographs they took afterward broke new ground for many of them. They saw they could produce whatever image they wanted. Scott Huff hadn't had any luck with his pictures until then, but he strode into my room triumphant with his roll of dream

pictures. He told me they would be good if he could develop them right. His hands trembled as he agitated the developing tank, but he had no problems, and a fine series of pictures—"A flying dream"—resulted. Allen Shepherd had a fight with his best friend, Ricky Dixon. He and Ricky had swapped knives and Allen felt he'd been shortchanged. They weren't speaking to each other until one night Allen had a dream that he'd killed Ricky. He decided to make a photograph of Ricky dead in the forks of a tree. He asked Ricky to pose for him, and during the making of the photograph the two boys made up.

Others didn't need such urging to experiment. Denise Dixon and Russell Akeman loved to take pictures. Russell lived with his grandmother, brother and sister. He wanted to be a photographer and was encouraged that there was a famous photographer named Russell Lee. Russell's subject matter was limited to himself, his animals and family, but his enthusiasm led him to an understanding of photography beyond most of the other students'. His grandmother's farm sits below the road in a little holler of its own. There are lots of animals around—chickens, ducks, a horse, cows and pigs. It is an old-time farm that still looks like it was carved out of a wilderness. It has been kept with such care for generations that the way the fields are laid out, where the lawn ornaments are placed and how the outbuildings have been mended are all part of the nature that surrounds the neat white wooden house. The compositions of Russell's photographs sometimes mirror the natural balance and playfulness of the landscape of his grandmother's little holler.

You can see in Denise's photographs that she was a beautiful ten-year-old. She was the best dressed and most ladylike of the girls in her class. With the first roll of film she took I noticed that she had a distinctive and original sense of composition, and she never ran out of ideas as some of the others did. I visited her at home several times. She had set up her room as an oversized doll house with stark white walls and a few posters of animals and family portraits. She created tableaux with her dolls on the bureau, night table and bed, and likewise in her photographs she made up fantasies involving her twin brothers, Phillip and Jamie. Her careful arrangement of her room and her dress was similar to the care she took in the composition of her photographs. When I asked her to docu-

Wendy Ewald

ment her Thanksgiving dinner, she took a picture of the turkey on a plate on the bare formica table. As with her room she included only what was essential.

Denise worked with me from the fourth through the sixth grade. In the seventh grade she became a cheerleader and basketball player. She wore makeup and flirted with the boys in the eighth grade. She took fewer pictures and finally told me she wanted to quit photography class. She had lost her interest but couldn't explain why.

Russell started taking pictures when he was in the fourth grade and didn't stop until the summer after the seventh grade. He grew a lot during the summer and his voice changed. I taught him how to use a $2^1/_4$ twin lens reflex camera to try to renew his interest, but he began skipping photography class. He would say "I'll come in a minute" and never show up, or if I went to his room to look for one of his classmates he would avoid my gaze. I suspect he didn't like the attention, which earlier he had sought, that he got from me or from his pictures. His ambition to be a photographer I think seemed childish to him now. He knew it was more likely that he would be a coal miner.

I had fallen in love with Russell and Denise during those years. They were my companions. Once Denise and I stretched out on her bed and talked for hours about her dreams and premonitions. Russell and I photographed together at his grandmother's house. A couple of times I held my breath as I watched him climb to the roof of the barn to take a picture with my Hasselblad. We were like accomplices in a secret game. We knew as photographers that we sometimes had to trick the adults into letting us take the pictures we wanted. It may have been love that propelled them to photograph in relationship to other forms of love in their lives, but when they reached puberty they grew up. They became mountain men and women with the limitations and protection of their society. Amy Cornett quit school and married Billy Caudill. Luke Capps joined the army, and Bonnie, who wanted to be a lawyer, is a waitress at the Pizza Hut.

I couldn't push Denise or Russell to continue. I realized I was trying to hold on to a period of their lives that they had let go of. Their eloquence with the camera was a passage of childhood. They would have to become

conscious of their natural abilities and become photographers if they were to go beyond the point they had reached. Maybe at some other time they will pick up a camera again or express themselves in another way. Their pictures are in their family albums or pasted on the wall, mixed in with the pictures taken by their parents or by the studio photographer at the dime store. Junior Childers came by the other week with his new wife to show her the darkroom and tell her about the time they used to take pictures.

Wendy Ewald

Jed Perl

The Art of Seeing

The Time Element

Every couple of months, I hear an artist or an art historian announce, in a voice suggesting both amazement and frustration, "Nobody knows how to look anymore." They may be thinking of the nonplussed reactions of students whom they have taken to a museum, or of the smug theoretical pronouncements of colleagues, or of the anxious uncertainty with which friends who are not in the arts discuss the exhibitions that they see. These artists and art historians are not censorious so much as they are rattled. They believe that a lot of people are robbing themselves of a tremendous experience. I know exactly how they feel, because there are many days when I go to the galleries in New York and find myself concluding that none of the people who are selecting and promoting contemporary art know how to look. I am sure that some artists are doing work that is worth a second or third look, but most of what the galleries and museums show and most of what people talk about repels curiosity. I find myself going through whole buildings and streets and neighborhoods full of galleries that are operated and patronized by people who seem to care so little for seeing that they might as well have shut their eyes.

Confronted with this situation, my initial reaction is to say that people have lost the ability to look. But the reality may be stranger still. I sus-

pect that what I am encountering is not a generation that doesn't know how to look, but several generations that have been trained to look in a particular way. If you make any effort to follow the way that art, especially contemporary art, is discussed in the art magazines, the museums, and the universities, you will find it difficult to avoid the impression that there is a method to this widespread inattention. People have an idea that to look at art in a sophisticated and up-to-date way means that you do not look at it very long or very hard. There are late-modern and postmodern variations on this approach. Some trace it back to Duchamp, others all the way to Diderot. Whatever the genealogy (and it can get fairly complicated) the result is an almost universal feeling that art ought to be taken in quickly, even instantaneously—that a painting or sculpture should hit you with a bang. After which, of course, you can talk or theorize about it forever.

Let's be absolutely clear about what kind of visual experience has been, if not yet lost, then marginalized. What people are no longer prepared for is seeing as an experience that takes place in time. They have ceased to believe that a painting or sculpture is a structure with a meaning that unfolds as we look. This endangered experience is not a matter of imagining a narrative; it involves, rather, the more fundamental activity of relating part to part. We need to see particular elements, and see that they add up in ways that become more complex—and sometimes simpler—as we look and look some more. The essential aspect of all the art that I admire the most, both old and new, is that it makes me want to keep looking. A painting or a sculpture—by Sassetta, by Corot, by Brancusi—engages the viewer by means of a range of particularities and unities. We take in these elements and combinations of elements in different ways, at different speeds. Sometimes we take them in serially, sometimes as overlapping impressions, sometimes simultaneously. We may approach the same element—a figure, a curve—from different directions. A work of art can reveal alternative, even in some ways contradictory, kinds of logic. And logic can collapse into illogic, from which a new logic can emerge. Of course the artist exerts considerable control; but the greatest artists enable us to make our own way through a composition, so that we find our own kind of freedom within the artist's sense of order. If I were asked to name one group of twentieth-century paintings that

Jed Perl

epitomizes the shaped yet boundless experience that I am attempting to describe, I would point to Braque's *Studio* paintings, those symphonic celebrations of the particularity of seeing, of the insistence on unity as a delicious, forever-just-beyond-our-grasp dream.

If there is so much to be said for particularity and paradox, why has the unity idea triumphed so totally? The first thought that comes to mind is that this is not really so strange, considering that we live in a world where art marketing dominates art, and where the work that reveals its meaning instantaneously is probably going to be the easiest to sell. I mean sell in the broadest sense—not just to collectors, but also to curators and museumgoers and critics. There are kinds of work, such as Conceptual Art, that by definition defy extended looking (while inviting endless discussion). Those who have never much cared for theory may want to argue that with theory ascendant, there is simply less and less time left to look. But I would point out that the ideal of immediate, all-in-one impact has become a touchstone even for people who by and large reject theory. In 1982, when Peter Schjeldahl wanted to praise David Salle's canvases, which were then at the forefront of a fashionable return to painting, he described Salle as "an artist who evokes virtual Rorschach readings of critics' pet tendencies." What could provoke a quicker reaction than a Rorschach test? And just this spring Dave Hickey—a critic who, like Schjeldahl, has a reputation as a postmodern aesthete—saluted some new paintings by Ellsworth Kelly (in a catalog for the Matthew Marks Gallery) as "an irrevocable fait accompli." Hickey hastened to add that this "demands narrative," but his protracted "accounting of the contexts and processes" belongs not to seeing but to thinking about seeing, which is something else.

Seeing is not easy to talk about, because the talk can easily shift attention away from the primary experience, which is by definition nonverbal. You can talk yourself into distinctions where none exist, and you can end up confusing talking about seeing with seeing. Recently, as I made my way through a number of books that deal with how art has been seen and understood in the past fifty years, what occurred to me was that large areas of agreement among leading art theorists and historians are often masked by all the arguments that have been waged between the Greenberg-type formalists, the advocates of French-style theory, and sev-

eral other varieties of late moderns and postmoderns. I am aware that there are substantial matters of philosophy, taste, and outlook that separate Clement Greenberg, who died in 1994 at the age of eighty-five and is now, a few years later, the subject of *Clement Greenberg: A Life,* by Florence Rubenfeld; and Michael Fried, who was much influenced by Greenberg in the sixties when he wrote an influential series of essays that he has finally made into a book called *Art and Objecthood;* and Yve-Alain Bois and Rosalind Krauss, whose book *Formless: A User's Guide* is a leading example of the French-style theory for which Fried does not care. But I would argue that they are all inclined—together with a poststructuralist such as Norman Bryson and a postmodern aesthete such as Dave Hickey—to use their eyes in the same way. The people who are now regarded as the most sophisticated interpreters of art are instinctively disposed to believe that a great work of art is a work that they see totally at once, and this belief is grounded in such a pre-analytical mix of old-line academic, antiformal Dada, and postwar high-modern assumptions that even the finest minds cannot escape from what amounts to a visual prejudice.

The phenomenon is complicated by the fact that immediate impact and seamless unity are legitimate and recognizable values in art. But the immediacy and the unity that now dominate fashionable taste are shallow. The new unity has neither weight nor force; you feel no struggle, no resolution. And there is no surprise lurking in the immediacy of a lot of recent art. Nothing mysterious or submerged is being brought forth—in the way, say, that the near-symmetry of Mark Rothko's paintings can be exciting because (as David Smith said about his own work) "the afterimages of parts lie back on the horizon, very distant cousins to the image formed by the finished work." When, thirty years ago, Michael Fried praised paintings and sculptures for their "*instantaneousness*" and "*presentness,*" the italics helped to convey the electric-shock quality that he was after. By now, however, unity and immediacy have become uninflected, tyrannical experiences that rob art of all its ambiguous fascination.

In offering a response to the big-bang theory of seeing, I cannot enter an ongoing dialogue, because those of us who believe that seeing-through-time is simply how art was, is, and will be experienced have by and large been shut out of the discussion. What I can offer is an alterna-

tive view, a view that is grounded, I believe, in the very beginnings of modern art, as well as in earlier traditions. Much more than a theoretical argument is at stake. The experts who deny the time element in art so insistently have brought us to a point where contemporary painting and sculpture that requires concentrated, adventuresome attention—whether the work is representational or abstract or somewhere in between—is regularly shunted to the side, if not eclipsed. If there has been one sure rule in recent years it is this: the more that an artist asks us to look at a work over a period of time, the more a work drops beneath the radar screens that criticism has set up to track the contemporary scene. So far as I am concerned, if you are looking for an all-in-one impact, you're missing most of the important painting and sculpture that artists are doing today.

Chardin's Complications

Just to make sure that there is no confusion about the kind of experience I am defending, let's consider what happens when we look at a transcendentally great work of art. The painting I have in mind is a still life by Chardin, *The Brioche*, from 1763, in the Louvre. This is a small painting—just over a foot and a half high and just under two feet wide—and so you might expect to be able to take it in all at once. But when I first look at *The Brioche*, it is Chardin's way of differentiating one substance from another that holds me. And I linger over his distinctions. He gives us the exact character of cherries and peaches, of biscuits and a crusty brioche, of porcelain and glass. And even as this naturalistic virtuosity is astonishing me, I am also noticing (as people have noticed since the artist's day) Chardin's habit of playing a hide-and-seek game with his own peerless illusionism by enriching his surfaces with strokes of strong, virtually unmixed color. I begin to be caught up in the poetic mood that Chardin spins, as he turns our attention back and forth, between paint-as-paint and paint-as-illusion, between paint-as-illusion and paint-as-paint.

Initially, I am not especially caught up in the totality of Chardin's composition, though I am aware of the overall—and on first glance, not especially daring—symmetry, which fans out from the grand spiral of the brioche that is topped with a sprig of orange blossom. There is some-

thing pleasing about the simplicity of the arrangement, about the way that Chardin draws me into an almost childlike game of counting things. I notice that there are three cherries and three biscuits, but only two peaches. And then I find myself studying those three cherries to the exclusion of everything else, and that is the moment when the composition really begins to kick in. Damned if Chardin hasn't turned these cherries into a sort of reeling circle dance, with their gleaming fruit and curled stems creating a mesmerizing red-and-green whirlpool. That tiny cyclone might be the engine that powers the whole composition. The force of those cherries is certainly out of all proportion to the space that they occupy, but then this is a painting full of strange, almost Manhattan-skyline-like shifts in scale. So now I may have found the key that unlocks *The Brioche.* I want to compare objects in the extreme foreground, such as the cherries, with forms that tower over them, such as the glass carafe full of liqueur and, of course, the brioche.

I find myself making lots of comparisons. I notice that the whirlpool of the cherries is echoed, in a slowed-down version, by the spiral of the brioche. Soon I am observing that the handle of the Meissen bowl points deep, deep into space. And if I connect that imaginary trajectory with another imaginary trajectory, suggested by the angle of one of the biscuits, I find them converging to create a sort of triangle, with an apex that's "behind" the brioche. Chardin's symmetries are beginning to be interestingly echoed and reiterated. The still life is becoming landscape-like. I can think of the brioche as a sort of Mont Sainte-Victoire—surmounted by a flower-tree, that is, the orange blossoms—that I move away from and return to by several different paths.

By now I feel the multiplying complexity of Chardin's compositional architecture: the curves and curls of brioche, cherries, peaches, patterned bowl, all set in an inexhaustible counterpoint with the relative rectilinearity of the liqueur carafe, the shelf, the biscuits. Chardin uses his lyrically there-but-not-quite-there handling of paint to interweave episodes of intense hue, earth-toned shadings, and diffused, grayish atmosphere. And of course I am also considering the peculiarities of this particular arrangement of objects—the Meissen bowl without an accompanying coffee or tea service; the elegant liqueur bottle next to the biscuits that haven't even been set on a plate. The painting is about differ-

Jed Perl

entness and connectedness, and the relationships are so thrillingly elaborated that you never want the complications to come to a conclusion.

A picture by Chardin is a dream of unity that we glimpse through an atmosphere saturated in particularities, and it is our feeling for those particularities, and for their connectedness, that carries us into the dream. I believe that the same can be said for many, if not all, of the greatest works of art. In the museum and in the gallery, I want the parts to add up—and to multiply—in unexpected ways. This is the process that gives art its rhythm, its flow, its mesmerizing time element. This is certainly what holds us in Analytical Cubist paintings, those anatomical blueprints for the art of our century, which often seem composed of the bones and sinews of Chardin's still lifes. In one of the great Picassos or Braques of 1911 or 1912, we will pick out a naturalistic detail (a bit of rope or wood, say) set next to a line that's suspended in thin air. We see shapes that are apparently solid at one end and fade off into nothingness a few inches farther on. In Braque's *Homage of Bach*, words, a musical instrument, and echoes of classical architecture play a fascinating hide-and-seek with one another, and we follow the clues.

In his "Creative Credo" (1920), a classic text of modern art, Paul Klee observes that "space itself is a temporal concept." Klee focuses on the narrative possibilities of Cubist construction, and in doing so he insists on the indissoluble connection between modern structures and earlier European art. He asks: "And what about the beholder: does he finish with a work all at once? (Often yes, unfortunately.)" Klee goes on to say that a painting is "first of all genesis." "In the work of art, paths are laid out for the beholder's eye." These paths create movement, an opening-up sensation. The same idea is reframed, a generation later, in the writings of Hans Hofmann, the great teacher among the Abstract Expressionists. He argues that "movement is the expression of life. All movements are of a spatial nature. The continuation of movement through space is rhythmic." Hofmann also celebrates immediacy, but he wants the immediate sensation to pull the viewer into an experience that expands as we look and look some more. And if you are susceptible to the rhythmic impulse that fuels those movements, you will find that many of the conflicts between form and context that have preoccupied the theorists for decades and even generations begin to vanish.

If there is time to look, then there is no conflict between noticing the character of a smile in a portrait one moment, the way the tones of flesh vibrate against the distant landscape a little later, and the cut of the sitter's clothes later still. What people tend to divide into form and content is woven together into the rhythmic movement of a visual experience.

The Quick Fix

Why has this expansive way of looking, which is lodged so deep in our experience, been rejected? And why has this way of looking often been said to be anything but modern? Familiarity is no doubt an element here: inevitably, taste is conditioned by the work that people know best, and for years a great deal of the painting and sculpture that has been displayed most prominently has not exactly encouraged anybody to look long or hard. No matter what one's particular feelings about the work of Duchamp, Pollock, Judd, Warhol, and Stella happen to be—and these are artists of radically different characters and values—we can probably agree that the audience that has grown up regarding this as standard fare is going to believe that they should take art in quickly, instantaneously, all at once. And many people would argue that this speed-reading fits right in with the pace of contemporary life.

The obsession with unity may be grounded in a belief that today's artists must create products that can compete in an environment in which it sometimes seems that nothing is left but brand identity. Many people are convinced that the modern world, with its acceleration, commercialization, and cultural homogeneity, is always hostile to particularity and idiosyncrasy. In some parts of the art world it is now assumed that no artist, no matter how gifted, can hope any longer to establish a detailed, particular, extended relationship with anybody in the audience. These ideas, of course, are not all that new. You can trace them back to the go-go mood of the postwar years, when a hip triumphalism became the upscale mood in New York City, and it didn't take any particular intelligence to see Color Field painting and Pop and Minimal Art as spin-offs of a slam-right-through way of life.

I think I know why Clement Greenberg's ideas held such a fascination for many people, especially in the early sixties. By arguing that art-

ists, at least since the Renaissance, have sought a seamless, peremptory impact, he gave the sleekly upbeat painting of his own day a sophisticated traditionalist sheen. Greenberg was without a doubt the most searching exponent of the idea that we take in great art all at once. Of all the critics who flourished in those years—I am thinking not only of an art critic such as Harold Rosenberg, but also of literary critics such as Philip Rahv and Lionel Trilling—Greenberg is surely the greatest prose stylist. He knew how to use his blunt lucidity to put over his big idea. He could make people believe, as he believed, that twentieth-century art was moving toward its own kind of bluntness—toward a way of treating "the whole of the surface as a single undifferentiated field of interest [which in turn] compels us to feel and judge the picture more immediately in terms of its over-all unity." There is no question that Greenberg's ideas are grounded in the artistic excitement of his early manhood, when a new kind of stripped-down abstraction was the hot news in New York. I suspect that what happened to Greenberg was that after a while he began to want to make that part of the truth into the whole truth; he wanted to line up the whole history of art behind the Pollocks that he adored. By the early sixties, he had turned "instantaneous unity" into his mantra—a key to all mythologies. When he announces that it was the fifteenth-century Italian painters who discovered "that instantaneous, compact and monumental unity . . . to which Western pictorial taste has oriented itself ever since," I have to wonder if this isn't closer to a description of a billboard than of a Masaccio.

If there is anything to be learned from the tone of mixed bewilderment, anger, and awe that marked the discussions of Greenberg in many of the reviews of Florence Rubenfeld's workmanlike 1997 biography, it is that even now nobody quite knows what to make of him. There are a number of reasons for this ambivalence. Greenberg had a flair for playing the art world game that is rare in a man of his refined intelligence, and he convinced many people who should have known better that taste was a marketable commodity. In the process he was not averse to steamrollering anybody who did not get with the program, and those people have not always been quiet, nor should they be. It would be absurd to argue that Greenberg's opinions are directly affecting the taste of gallerygoers and museumgoers today. The contemporary audience has only the vagu-

est familiarity with his ideas. By the same token, Duchamp's thoughts (to the extent that one can determine what they are) remain the purview of specialists; and the same goes for the ideas of such contemporary writers as Michael Fried, Rosalind Krauss, Yve-Alain Bois, and Norman Bryson. But I do believe that the sophisticated public is picking up on fragments—inevitably popularized and frequently corrupted—of all of these thinkers' ideas; and by now there is a kind of theoretical gestalt that hangs heavy in the art world air.

Everybody from the formalists and the Neo-Dadaists through the post-structuralists and the academic Marxists seems to believe that at least for the past 100 years the artist and the public have been becoming increasingly alienated from one another. This process is felt to have a historical inevitability, which in turn leads people to imagine that the kind of controlled journey that the artist might once have provoked in the viewer is now an impossibility. Duchamp, reflecting on the situation in a famous statement made in Houston in 1957, said that "to all appearances the artist acts like a mediumistic being." For Greenberg, the result of this historical development was an increasingly self-critical and inward-turning artist. I do not mean to say that the aesthetics of Duchamp and the aesthetics of Greenberg are the same, but their divergent ways of thinking about art do depend on a related assumption that the artist can no longer count on communicating complicated, expansive experiences in a detailed, lucidly articulated way. The Museum of Modern Art curator Robert Storr, in a deeply unsympathetic account of Greenberg's influence that he published at the time of the museum's 1991 exhibition, "High and Low: Modern Art and Popular Culture," remarked on the convergence of a formalism for which he did not care at all and a Dadaism for which he cared a great deal. Storr argued that if Greenberg's essential idea was that modern art was self-critical, then "junk assemblagists, Neo-Dadaists, and Pop artists" were continuing that process, since they "used the castoffs of mass culture to criticize that culture from within." Now self-criticism is at the heart of the unity idea; you keep whittling things away. The new unity is really a new simplicity. The logic of Storr's argument may be a bit difficult to follow, but I think it comes down to the rudimentary thought that a Johns *Flag* or a Warhol *Marilyn* is a distillation of the pop ethos, and as such is analogous to a Morris

Louis stain painting, which (at least for Greenberg) is a distillation of the Western color tradition. The aim of art is distillation. In both cases what's contemporary is unitary.

Many people have made this connection. As early as the forties, and frequently since the sixties, critics have observed, with varying degrees of comfort or distress, that the absoluteness with which Dada rejected all traditional ideas of composition and structure could seem to be leading in the same direction as Purist art of one kind or another. Even Michael Fried—in "Three American Painters," the introduction to a 1965 show of work by Noland, Olitski, and Stella, the abstract artists he admired and wanted to isolate from what he called the literalism of Minimal Art— had to admit that "just as modernist painting had enabled one to see a blank canvas, a sequence of random spatters, or a length of colored fabric as a picture, Dada and Neo-Dada have equipped one to treat virtually any object as a work of art." Both modernist painting and Dada, in other words, were all-in-one experiences. By the end of the sixties, all the art that the tastemakers believed was worth talking about, whether they wanted to praise it or damn it, was big-bang art.

The unity idea is by now accepted so widely as to defy analysis. Marxists admire Warhol for the same reason that the auctioneers at Sotheby's do; he makes a big, fast impact. And if you are a historian, you may want to wend your way back from Warhol's gay-themed all-overness to Pollock's macho version. At least that is what Rosalind Krauss has done in *Formless*, when she considers Warhol's oxidation paintings, the big metallic surfaces on which he had friends urinate in order to get the paint to change color. "Warhol's 'urinary' reading of Pollock's mark," she explains, "was insisting that the verticality of the phallic dimension was itself being riven from within to rotate into the axis of a homoerotic challenge." The urinary, the unitary. Krauss uses her newfangled theory like camouflage, but if you peel it off you find that her eye is still seeking the all-in-one experience that she learned from Greenberg years ago.

So far as the academy is concerned, the whole history of Western art, at least since the Renaissance, is based on instantaneous unity. In the seventies, Michael Fried turned from art criticism to art history and began to study the Salon painting of anti-Rococo France in the late eighteenth century. (Maybe this wasn't such a reach after Color Field, which was the

Salon painting of the sixties.) Fried believed that he had found, in Dide-
rot's defense of the narrative paintings of Grueze, another critic who saw
"the essence of painting in terms of instantaneousness." Fried became
immersed in old-guard mainstream French art theory, which insisted on
a unity of time in classical history painting. Never mind that some of
Poussin's most evocative masterpieces are temporally elastic, if not tem-
porally ambiguous. It sometimes seems that contemporary theorists
such as Fried and Norman Bryson are determined to repeal the elements
of paradox and ambiguity that are right there before our eyes in the Old
Masters. In his influential *Vision and Painting* (1983), Bryson observes that
what Titian—and Vermeer—create is "a single moment of presence. For
the painter, the irregular and unfolding discoveries of the glance are col-
lected and fused into a single surface whose every square inch is in fo-
cus." This is a description that jibes with no experience that I have ever
had with a Titian or a Vermeer.

Fried is a discerning thinker; he is troubled enough by the idea of in-
stantaneousness to argue that you can look for a long time, just so that "at
every moment the *claim* on the viewer of the modernist painting or
sculpture is renewed totally." And Bryson is in fact opposed to the mono-
lithic vision of painting—that Tyranny of the Gaze—that he would like
to reject in favor of the freedom of the Glance. Krauss, too, in the discus-
sion of Cubist collage in her book *The Picasso Papers* (1998), may be under-
stood as reinventing an idea of seeing-through-time that is really the
most natural thing in the world. But these historians are not necessarily
in control of the ideas that they purvey. And because they are inclined to
believe that they are close to the mainstream of taste, which for that very
reason they regard as never far from the truth, they have a way of ending
up in cahoots with some of the big-time museum and gallery people who
stuff the latest version of instant unity down our throats.

When Fried managed to demonstrate, at least to some people's satis-
faction, that the campy melodramatics of Greuze's paintings were proto-
modernist, he performed a great service for the postmodernists, and it
hardly matters whether he planned this or not. If Greuze's overcrowded
narratives lead us to Manet, then why can't that road just keep on going
all the way to the get-it-in-an-instant Cibachrome surfaces of Cindy Sher-
man's postmodern Greuzian allegories? As for Bryson, he has made it

possible to see Greenberg's celebration of instantaneous unity as a sinister ideological plot, and what could be more politically postmodern than that? Unity becomes the white male artist's way of not letting the viewers make up their own minds. What is lost, once again, is the idea of looking as an extended, responsive, evolving, back-and-forth interaction.

Unity and Particularity

There is no mystery as to why unity exerts such a pull. We do go to art for clarity. When you talk about a painting or sculpture, you say, "Now it's all coming together for me," or "I see how it adds up." We all hope for coherence. But there are many ways for a work to come together, and the character of even the most seamlessly convincing painting or sculpture is to be found in the unique confluence of elements and forces that makes up the whole. This is the important point that Meyer Schapiro made in 1966 in the essay "On Perfection, Coherence, and Unity of Form and Content." In that understated way of his, Schapiro chose not to place his remarks in a contemporary context, but I do not think it was an accident that the essay appeared in the mid-sixties, when Greenberg's idea of instantaneous unity was at its most influential. Surely Schapiro is lodging a protest against the whole drift of sixties aesthetics when he writes that "to see the work as it is one must be able to shift one's attitude in passing from part to part, from one aspect to another, and to enrich the whole progressively in successive perceptions."

Like Greenberg, Schapiro had been fascinated by the move toward all-in-one expression in the paintings of the Abstract Expressionists. But he nevertheless insists that wholeness is at best an elusive thing. Schapiro shrewdly points out that we sometimes experience paintings that are in a fragmentary state as magnificent wholes. He insists that certain kinds of incompleteness or irresolution can be precisely the elements that give a work its life-giving energy. He bids us to remember that there are many, many different ways in which a work of art can satisfy us, and that in order to arrive at this feeling of glorious complication, we may find ourselves approaching a work from a number of radically different directions.

Schapiro does not ask why this kind of peremptory unity might have

become such an obsession in the sixties. He could well have pointed out that the idea of unity—if not the unity of perception, then the unity of action in painting—had been a theme among the authors of treatises on aesthetics since the Renaissance. Certainly, this idea has a way of coming to the fore when the general conversation about art has lost its vital connection with the hands-on experience of the studio. By the late fifties, many artists in New York feared that American art's age of experimentation was moving toward academicism. And as Pop and Minimalism gave way to Conceptual and Environmental Art and then to postmodernism, the underlying problem remained the same. Perhaps the most recent guise that unity has taken is an obsessive narrative busyness, an image so saturated with small, frequently cartoonish elements that although they present an idea of variety, they are visually impenetrable—a postmodern anti-unity unity. A leading proponent of this approach is Lari Pittman, the painter whose labyrinthine pop extravaganzas were featured in three consecutive Whitney Biennials during the 1990s. From the sixties down to our day, fewer and fewer mainstream artists have been committed to the kind of pragmatic studio practice that acts as a brake on theorists who associate excellence with one or another brand of monolithic unity.

Anybody seeking a countertradition in recent decades will want to read the extraordinarily intelligent criticism that the painter Fairfield Porter wrote in the sixties. Porter was always unequivocally dedicated to paradox, particularity, and the ambiguities of looking, and he frequently grappled with the difficult question of why taste was veering in such a different direction. Time and again, Porter came to the conclusion that the mysterious process of looking at a work of art was in some fundamental way at odds with the push toward standardization that has characterized modern times. "Standardization," he wrote in 1966, "is the victory of the most probable; art is for the improbable and against the standard." In a 1969 essay on "Art and Scientific Method," he observed that "with the arbitrary and the particular, there can be no 'logical' communication at all, for the arbitrariness of the original experience will not survive a generalization that is necessary for logical communication." If Porter is correct, this may explain why the quickie-unity of late-modern and postmodern art has been such a success among corporate collectors. What, after all, would captains of industry make of the art that Porter pre-

Jed Perl

ferred—an art whose aim, as Porter said, quoting Wallace Stevens, was "without imposing, without reasoning at all, to find the eccentric at the base of design"?

I do not mean to suggest that corporate standardization is the same thing as the unity that Greenberg celebrated, or that the unity that Greenberg saw in the masterpieces of the past is the same thing as the inscrutable self-sufficiency of the found object. But I do believe that in the minds of the majority of contemporary tastemakers all of this is related. And I cannot avoid the conclusion that a rigid concept of unity that is as old as academic art theory itself has now been resurrected in a particularly pernicious form, a form that fits the art world's no-time-to-wait globalized vision to a T. The people who shape contemporary taste are inclined to believe that if a painter or sculptor pulls them in gradually, incrementally, the artist is probably not really doing much at all. Anyway, they have another appointment.

Even a lively, unstuffy writer such as Dave Hickey, the columnist for *Art Issues*, the hip Los Angeles magazine, seems so pessimistic about finding his preferred kind of quirky beauty in a painting or a sculpture that he ends up filling his essays with comments on anything but art. Hickey ranges from the Las Vegas show of Siegfried and Roy to old TV programs such as Perry Mason to his feelings while he "sat shivah for Chet Baker." I read Hickey's voice of unnervingly sweet sanity as a particularly clever and seductive response to the art world's closed-down horizons. Is there any wonder that people who have lost—or systematically denied themselves—the capacity to see should now talk in a way that is fancifully vague or theatrically overelaborated? Having convinced themselves that they have nothing much to look at, how could the people who are most involved with contemporary painting and sculpture not be in a state of perplexity—even of downright self-disgust? How could they not feel querulous and belligerent? And if the professionals feel like this, how can we expect the wider audience that goes to galleries and museums to believe that your imagination opens up as the work unfolds in time?

What is so demoralizing about the situation in which we now find ourselves is that the very painters and sculptors who offer us works of art with complicated, multiple points of entry are often rejected as present-

ing poorly organized, incoherent experiences. Artists who actually attempt to communicate with the audience are now generally the first ones to be dismissed as messy, as emoters—as vulgarians. That may be how many people regard Joan Snyder, one of the very best painters we have. Although the steady stream of visitors to her show at Hirschl & Adler Modern in the spring of 1998 demonstrated that there is still an audience that knows how to look long and hard, I had to wonder when a work as absolutely extraordinary as *A Sad Story Told by an Optimist*, the centerpiece of this exhibition, was passed over by the official art world as a nonevent.

This is a painting in which Snyder rages against order and unity. It's a huge composition—more than sixteen feet wide—full of structures that are shattered and reconstructed, just barely, before our eyes. This gorgeous three-part invention, with its overall orchestration of lemony greens and cadmium-alizarin-and-pinkish reds, offered an experience so complicated, in so many parts and passages, that a visitor couldn't take control of it; you just had to go with it and see what happened. In the beginning, at the far left of the painting, Snyder is literally tearing things up, as she unglues a corner of a collaged square. The viewer is taken through a series of metamorphoses in this painting, from the dream of absoluteness that is a grid of colored squares, through a chaotic landscape scattered with skull-like masks, and finally into a flowering field. In the center, Snyder punches a hole in the canvas and pulls us down into a slit filled with dark, crushed fabric. There's so much to see. You don't see it all at once.

Much of the power of the painting is in the way that you go through changes with Snyder and find things out in time. Only after a while did I notice, at the extreme lower right, in the midst of all her glorious orchestrations, this shocker: a black handprint and the crudely scrawled word "MOM." Here Snyder is daringly emotional. I would not have thought that an artist could get away with giving an elegy for a dead parent this crude immediacy; but it works because you discover the weight of Snyder's cry for her mother as an undercurrent, like the soprano's last, low moan at the end of a grand aria. Snyder is an artist who wants to communicate on multiple levels. She goes into the whole question of remembering a person and remembering their suffering and their death. She is in

search of lost time. And since she believes in the time element in painting, she finds it. But will a public that has been encouraged for decades to swallow art in a single gulp find the time to look at a painting until it begins to reveal its secrets?

To the extent that contemporary artists can make people look longer and harder, they must dare to give their work a complicated openness, a surprising particularity. Artists have to find ways to pull the audience in, for only when people come to understand that within a painting or a sculpture they can find a time that is outside of time will they want to keep looking. Only then will they see that although nothing in a painting moves—at least in the sense that sound moves in music or bodies move in dance—everything in a painting is alive. And then the surface opens up, and effects multiply, and you see more and more. You enter into an intimate imaginative collaboration with the artist. If the very idea of instantaneous unity comes out of a feeling that in the world things can happen with this much speed, a more circuitous and layered way of looking suggests a release from the compressed, fast-forward pace of daily life, which has always troubled people, and surely does today. If you can unlock a moment, you can enter a realm of freedom. Artists show the way. To look long is to feel free.

Laurie Fendrich

Why Abstract Painting Still Matters

I have been an abstract painter for about twenty-five years, and have taught painting and drawing to undergraduates for almost as long. From both perspectives, I have concluded that painting, in terms of its influence on contemporary culture, has been marginalized—it is a wallflower at the postmodern art party.

Take a prominent example of painting's situation as we approach the twenty-first century: The lists of last year's finalists for the contemporary art world's two Oscar-like awards—the Turner Prize, in Britain, and the Hugo Boss Prize, handed out by the Guggenheim Museum—included not a single painter. In fact, among many artists, painters and non-painters alike, it is quietly acknowledged that painting's impact on the culture is nil. Painting is seen as, at best, an esoteric activity for a few diehards. At worst, it is considered destructively elitist, a part of the "oppressor culture" of dead white European males. The general public—attached to movies, television, and computers—barely registers painting as having anything relevant to say. The only question left is whether there is any audience at all for painting and, if there is, how to preserve it.

This essay is a defense of abstract painting, the most difficult to understand and seemingly irrelevant kind of painting that exists. By limiting my subject to abstract painting—which focuses on structure and

builds an entire flat reality from color, surface, shape, traces of the hand, mistakes, and changes—I can best address the question of why anyone should continue to make paintings, when so many more visually powerful media are available.

In defending abstract painting, I must first toss overboard some excess baggage. I take as my model the iconoclastic abstract painter Ad Reinhardt, who thought that the claims of the other Abstract Expressionists in the forties and fifties amounted to poppycock. To give painting back its dignity, he set forth, both in his own paintings and in a series of "dogmatic" statements, exactly what abstract painting is *not*. Allow me, in the spirit of Ad Reinhardt, to set forth my own list of what abstract painting is *not:*

- First, abstract painting is not a vehicle for social or political change, even if its pioneers thought it was. Today, even more than in Reinhardt's day, if even a figurative painter paints a picture that argues a particular social or political point of view, its impact—in a society flooded with books, magazines, newspapers, photographs, movies, television, video, and computers—is ridiculously small. The possibilities are even fewer with abstract painting.
- Second, abstract painting is not avant-garde. It was in 1915, but it isn't anymore. In terms of its ability to shock anybody—the rallying cry of the now-defunct avant-garde—painting today is feeble when compared with the power of the media mentioned above.
- Third, abstract painting has never been, and most likely never will be, widely popular. Yes, its pioneers—Malevich, Kandinsky, Mondrian—all held utopian hopes for its universal appeal, but they were proved poignantly wrong. Abstract painting turned out to be too subtle, too self-referential, too slow, too demanding of the viewer's patience, and too easy to poke fun at ever to attract a mass audience.
- Finally, abstract painting cannot offer much of what we call Deep Hidden Meaning, in the way that religion or philosophy can. Put bluntly, abstract painting cannot provide a substitute for God—the loss of whom is the earmark of modernism. Indeed, the ability of abstract painting to move people at all is much weaker than that of other arts, such as music, theater, novels, or poetry.

On the other hand—to continue in a more moderate, but no less passionate spirit than that of Reinhardt—here's what abstract painting *can* do:

- First, it offers what I'll call Little Hidden Meaning. To a viewer who can look at a still image (for some, a difficult prospect), and who is knowledgeable enough to place an abstract painting in the context of modern art as a whole, abstract painting offers a *de facto* philosophical point of view on life. There is a mistaken notion, coming from our lingering attachment to Romanticism and from our own narcissistic age, that abstraction is always about self-expression. In the broadest sense it is, of course, but it is also about ideas—the complex struggle between order and chaos, for example, or how the flux of the organic world modifies the rigor of geometry.
- Second, abstract painting can enable us to be quiet. In the 1989 French movie *The Little Thief,* a character brought a roomful of people dancing wildly to rock 'n' roll to a standstill by bellowing at them to be quiet so that he and his wife could dance a slow waltz. Abstract painting makes for a quiet room in the arts, allowing for a slow waltz.
- Third, abstract art offers a counter to our society's glut of *things*. An abstract painting is itself a thing, of course, a part of the material world. But it reminds people of a world without things. It suggests the old idea, now barely remembered, that there might be a hidden, underlying order, which the transience of life's things can't affect.
- Fourth, abstract painting is often, quite simply, beautiful—although that assertion is subject to tremendous dispute. Artists from the birth of modernism on have substituted the pursuit of truth for the pursuit of beauty—truth in perception, truth in form, truth in materials. Many artists—rightly—are suspicious of the very idea of the beautiful, because it so easily petrifies into some rigid standard. Once locked into place, "beauty" obliterates the wide array of subtle variations within it. In addition, politics surrounds beauty, making the subject difficult to discuss directly: For many, notions of the beautiful are simply "cultural constructs," used by dominant cultures to suppress "the Other."

Most problematic of all, folded up and hidden within the notion of beauty are conflicting values. Beauty implies an inequality in the way

Laurie Fendrich

things look. If there is beauty, there is ugliness, and everything else in between. That kind of ranking offends our democratic sense of justice, because we moderns have defined justice as that which most closely approximates equality.

But some people can't help their "elitist," or meritocratic, impulses when it comes to aesthetics, and are struck dumb by how utterly beautiful an abstract painting can be.

- A fifth virtue of abstract painting is that it is not a story, particularly not one from the most readily accessible side of culture, which is all stories. We are bombarded by endless stories—in television shows, advertisements, novels, movies, and virtual-reality games. We are constantly teaching and preaching, persuading and dissuading, by means of telling stories. Picking up on that aspect of our culture, many non-abstract painters have inserted stories, or "narratives," into their paintings. But abstract painting resists narration and presents itself all at once, as a whole or a oneness that cannot, and never will, tell a story.

- A final virtue of abstract painting is its very uncamera-like, uncomputer-like nature. The camera is so powerful that many people have reached the point where they can see the world only photographically or cinematically, and have lost the ability to see it in other ways. Before long, people will see the world only digitally.

What abstract painting offers us at the end of the twentieth century is, in sum, a useless non-story, a non-blinking "thereness," without reference to anything other than itself and its own tradition. It defies translation into data, information, entertainment, rational image, or any kind of narrative. It presents an ineffable balance of sensation, experience, and knowledge. In the midst of a world in which everything we see is morphing into something else, abstract painting is one of the few things left that allows us to see the possibility of something's remaining constant.

If what I am saying about the virtues of abstract painting is true, then why isn't there more interest in this art? It won't do to begin listing all the abstract painters around, because the point is that few people pay much attention to them, compared with either figurative artists in general, or new-media artists working with video and sound installations. Yes, ab-

stract painters still exist, but they are an aging lot, for the most part ignored. More worrisome is the seeming absence of a new generation of young and passionate abstract painters. How is it that abstract painting, a major player in most of twentieth-century art, has arrived at this sorry point, where it is barely a contender?

And how is it that painting in general, not just abstract painting, has arrived at this point?

I suggest that the answer is rooted in two irrevocable changes that took place in the nineteenth century: First, the invention of photography, in 1839, and second, the general upheaval in philosophy. The invention of photography allowed anybody, even someone who had no drawing or painting skills, to fix an image of the real world onto a flat surface quickly and accurately. The painter suddenly seemed irrelevant and slow in his method of replicating the appearance of reality.

More important, photography threw into question the whole *raison d'être* of painting. For if the camera was recording the world objectively through light rays bouncing off objects, then painting, by comparison, looked subjective, even fictive. If painters couldn't compete with the camera in mimicking reality, they would assert an alternative objective truth: All individual perceptions are true—at least to the perceiver—and therefore equally valid. Impressionist artists in the 1870s and 1880s, for all their stylistic differences, shared the conviction that it was the individual artist's vision that was objectively true.

Telling the truth about individual perception (Impressionism) quickly broadened to become telling the truth about individual feelings (Expressionism), reaffirming the fact that a major shift had occurred. That fundamental change in outlook changed the look of art in the modern age. It was a change from aesthetic effect, which relied on artifice—that is, faking, telling lies—to aesthetic intent, which relied on telling the truth, understood by artists as being sincere.

But what—in this kaleidoscope of individual "truths"—would become of beauty? After Darwin and Freud, artists didn't concern themselves with beauty anymore, except as a byproduct, or an aside, as they manipulated and played with form. Philosophy tried to come forth with a solution. It would protect beauty by separating it from destructive scientific analysis, and leave it alone as a "subjective" judgment. Philosophy

Laurie Fendrich

yielded its primary position as objective interpreter of the world to science. Science then broke loose, leaving everything else behind, including poor philosophy, as subjective rubble. That rubble reconstituted itself as the stuff of relativism—the idea that moral and aesthetic judgments are subject to continual flux. Relativism had been around at least since Plato, of course, but the modern age marked the victory of the relativist position.

The relativist reply to practically any pretension to universal truth, beauty, or authority is, in effect, "Oh, *yeah?*" The hatchet man of relativism is irony. To condense an awful lot of the history of twentieth-century art into one sentence: The past eighty years have consisted essentially of a battle between the ironists, who have reveled in the impossibility of universal truths, and the holdout universalists, who've tried to reconstruct classical philosophical truths in a modern visual language. In other words, it's been Duchamp versus Mondrian. And Duchamp is the winner—although more by forfeit than by knockout.

It took Duchamp a while to win—until the 1960s. Until then, when Pop Art burst Abstract Expressionism's bubble, it had been coasting on its inflated reputation; at that point, Pop Art sprouted from the smart, witty seed that Duchamp had planted a half-century earlier. By simultaneously mocking and celebrating the modern culture of "stuff," Pop made the abstract painter's self-absorbed retreat look both elitist and silly. To be sure, Pop Art consisted mainly of paintings on canvas. But they were self-destructive. Pop Art's implied message was that it was the appropriated images that counted—the Campbell's soup cans, Marilyn Monroe—and not the way in which paint was put on the canvas. Painting had always been profoundly centered on the artist's touch, but now painting concerned the content or image.

Since World War II, our culture has steadily evolved into what we identify as "mass culture"—one in which millions of people's interests are simultaneously and speedily gratified through popular music, movies, sports, and celebrities. Fewer and fewer people care any longer about the strange, slow activity called painting. Beginning in the late sixties and early seventies, young artists, drawn to the new art forms of installation, performance, and video art, abandoned painting in droves. They had

grown up with TV and rock 'n' roll; they were hip, smart, and sharp; they understood and embraced the seductiveness and power of popular culture, and they wanted in on it.

We have now arrived at a division in the art world: hip and trendy on the one hand, reclusive and out-of-it on the other. How can abstract painters who want to have an impact on their culture continue in the face of that?

First, they must aggressively separate themselves from popular culture, rather than strive to be bit players. Abstract painters have to become, philosophically speaking, difficult and cantankerous, because to survive, they must reassert the distinction—discredited by postmodernists—between "high" art and "low" art. They must reargue the case for high art—an art requiring a subtle, sensitive, experienced, and even exceptional viewer. Abstract artists are making paintings that cannot be understood by everyone. They need to admit that to find meaning in abstract painting takes some work, and even some help.

And abstract painters ought to celebrate loudly, rather than apologize for, the convention-bound nature of their artwork. These artists work within a rectangle, they use paint on canvas, and they follow a century of developed traditions of abstract painting. The revolution itself—the early-modern moment that invented abstraction—must have been electrifying, but that moment is forever over. For contemporary abstract painters and their viewers, the experience is profoundly different from what it was for their revolutionary forebears. Abstract art is a quiet pleasure rather than a dizzying thrill. The conventions are established, just as in baseball, and to derive pleasure from abstraction requires accepting its basic rules rather than continuously deconstructing them.

Yes, abstract art is elitist, and abstract artists should be up-front about that. But you don't have to stop loving *The X-Files* or the fights to understand and like abstract art. Nor do you have to be a white male of European royal blood. Yes, it is a product of European culture, but so are airplanes, computers, penicillin, and this essay. There are abstract painters, and patrons of abstract painting, of all races and both sexes.

Today, many, if not most, young artists trying to get a rung up on the art-world ladder don't care one whit about painting or its tradition in Western history. In fact, other than the fashion for discovering one's

Laurie Fendrich

"roots," they are not interested in seeing history as something to belong to, or to be a part of, or to carry forward. Although many young, non-white artists indeed refer to their racial heritage in their art, the issue for them is more identity than aesthetics. The point is, most young artists (whatever their race or sex) prefer to see history, especially art history, as a massive amount of information that at times is useful for rummaging around in for ironic references, but which mostly is a pain in the neck and best left ignored.

If we pull back from the abyss of Nietzsche's picture of our modern condition, we can take from him one workable premise: It is history, used correctly, that separates us from the lives of dogs, cats, and cows. But what, exactly, is the correct use of history? People today distrust it. They want to know who's doing the telling and why, because they are convinced that knowledge is a smokescreen for power.

Unfortunately, however, it is only when the sincere, non-ironic use of visual history is coupled with the particular desire to make images that the young artist, in particular, can learn the visual language of painted abstract images and the meaning of abstract painting. No matter what, some people—even some artists—will never "get" abstract painting, for reasons that range from their belief that all art is political to their poor visual aptitude. In the end, abstract painting is going to attract an audience more likely to read the *Aeneid* in Latin than to watch Sarah McLachlan on MTV.

But small as its audience may be, abstract painting can, indeed, say something about contemporary culture. As a colleague of mine from Hofstra University, the late Michael Gordon (himself a painter), often argued, it sets up a powerful moral parallel to the way in which we lead our lives. Abstract painters don't start their paintings in a vacuum. Rather, they build on the foundation of historical abstraction. Individual paintings are the result of an accumulation of errors, wrong turns, corrections, and resolutions. Abstract painters paint the way we all lead our lives—building on and rebelling against the givens and the choices, the purposeful actions and the accidents. An abstract painting, then, offers the perfect visual metaphor for life.

George Orwell said that every man at fifty has the face he deserves. In virtual time and space, there is no fifty-year-old face. Everything is a

toggle choice that wipes out the previous smiles or frowns and obliterates "bad" or "wrong" choices. In a computer image, of course, there no longer exists even the concept of a mistake, since all evidence of it is simultaneously retrievable and destroyable. When we take away the ability to make a real mistake in art, one that can't be wiped out, the final image has no wrinkles. It carries only a thin, stiff veneer, like the continuously lifted, stretched faces of sixty-five-year-old Park Avenue matrons. At a glance, those ladies look quite fine. But a longer look yields blankness. It is through our errors and, indeed, our sins, both in art and in life, that we gain the capacity for innovative improvisation and possible redemption.

Before modernism, painting was the noise in the culture, because it attracted attention. Now, the culture is the noise, and painting—especially abstract painting—attracts little attention, either in the culture at large or in the art world. Today, abstract painting's saving virtue is that it offers us quiet, not noise. There is indeed a cultural crisis at the end of the twentieth century: the continuous flux of everything, and the death of stillness. Abstract painting cannot change our culture, but neither can installation art, computer art, nor new-media attempts at appropriation, no matter how smart and savvy they are. Those art forms that appropriate the popular media are doomed to look forever pale in comparison to them, or worse, to be sucked down into their vast black hole. The power of abstract painting is this: It is a world beautifully separate from our postmodern, materialistic, morphing, ironic, hip age.

Laurie Fendrich

Lucy R. Lippard

Doubletake

The Diary of a Relationship with an Image

First Take

I am surprised by this photograph* which seems so unlike the conventional images I've seen of Native people "taken" by white people. It is simple enough—a man and woman are smiling warmly at the photographer, while their little girl smirks proudly. The parents are seated comfortably on the ground, the man with his legs crossed, the woman perhaps kneeling. The child stands between them, closer to her father, holding a "bouquet" of leaves. Behind them are signs of early spring—a tree in leaf, others still bare-branched.

I'm trying to deconstruct my deep attraction to this quiet little picture. I have been mesmerized by these faces since the postcard was sent to me last month by a friend, a Native Canadian painter and curator who found it in a taxidermy/Indian shop (he was bemused by that conjunction). Or maybe I am mesmerized by the three cultural spaces that exist between the Beaver family and Mary Schaffer and me.

They are not vast spaces, although we are separated at the moment by a continent, national borders, eighty-four years. They consist of the then-present space of the subjects, the then-present, but perhaps very dif-

* *Sampson, Frances Louise, and Leah Beaver, 1907,* taken by Mary Sharples Schaffer Warren. From the collection of the Whyte Museum, Banff, British Columbia.

ferent, space of the photographer, and the now-present space of the writer in retrospect, as a surrogate for contemporary viewers. Or perhaps there are only two spaces: the relationship between photographer and subjects then and between me/us and the photograph now. I wonder where these spaces converge. Maybe only on this page.

Good photography can *embody* what has been seen. As I scrutinize it, this photograph becomes the people photographed—not "flat death" as Roland Barthes would have it, but "flat life." This one-way (and admittedly romantic) relationship is mediated by the presence/absence of Mary Schaffer, who haunts the threshold of the encounter. I am borrowing her space, that diminished space between her and the Beaver family. She has made a frontal (though not a confrontational) image, bringing her subjects visually to the foreground, into the area of potential intimacy. The effect is heightened by the photograph's remarkable contemporaneity, the crisp "presentness" which delivers this image from the blatant anthropological distancing evident in most photographs of the period. The Beavers' relaxed poses and friendly, unselfconscious expressions might be those of a contemporary snapshot, except for the high quality of the print. At the same time they have been freed from the "ethnographic present"—that patronising frame that freezes personal and social specifics into generalization, and is usually described from a neutral and anonymous third-person perspective. They are "present" in part because of their impressive personal "presence." A certain synchronism is suggested, the "extended present" or "eternal present" cited by, among others, N. Scott Momaday.

What would happen to the West, Johannes Fabian has mused, "if its temporal fortress were suddenly invaded by the Time of its Other."[1] I think I've been invaded. I feel as though I know these people. Sampson Beaver and his wife seem more familiar than the stiff-backed, blank-faced pictures of my own great grandparents, the two pairs who went West in the 1870s, among those pushing their way into others' centers from the Eastern margins of the continent.*

* My great-grandfather, Frank Isham—teacher, businessman, dairy farmer, mining engineer, ranch foreman—built a little wooden schoolhouse in Dakota Territory. I have a photograph of it—bleak, unpeopled, rising from the plains as a rude re-

As I begin, I'm also looking at this triple portrait cut loose from all knowledge of the people involved—an aspect that normally would have informed much of my own position. With only the postcard caption to go on, my response is not neutral, but wholly subjective. I'm aware that writing about a white woman photographing Native people is a kind of metaphor for my own position as an Anglo critic trying to write about contemporary Native North American art. I'd rather be Mary Schaffer, a courageous woman in long skirts, who seems to be trusted by this attractive couple and their sweetly sassy child. How did she find her way past the barriers of turn-of-the-century colonialism to receive these serene smiles? And I want to be Sampson Beaver and his (unnamed) wife, who are so at home where they are, who appear content, at least in this spring moment.

Second Take

I showed the picture and my "diary" to a friend, who said she was convinced that the real relationship portrayed was between the photographer and the child, that the parents liked Schaffer because she had made friends with their little girl. Certainly the photograph implies a dialogue, an exchange, an I/eye (the photographer) and a You (her subjects, and we the viewers, if the photographer would emerge from beneath her black cloth and turn to look back at us). At the same time, the invisible (unknowable) autobiographical component, the "view point" provided by the invisible photographer "writer, naturalist, explorer, who lived and worked in the Rockies for many years" is another factor that shaped what is visible here. I have written to the Whyte Museum of the Canadian Rockies in Banff for information about her.

The cultural abyss that had to exist in 1906 between the Beaver family and Mary Schaffer was (though burdened by political circumstances and colonial conditioning) at least intellectually unselfconscious. It may

minder of all the unholy teachings to come. Frank and Mary Rowland Isham had their sod house burned out from under them by a "half breed" protesting the presence of white people.

have been further diminished by what I perceive (or project) as the friendly relationship between them. The time and cultural space that usually distances me—self-consciously, but involuntarily—from historic representations of Another is also lessened here. Schaffer's photograph lacks the rhetorical exposure of "authenticity." But the Beavers are not universalized into oblivion as "just folks" either. Their portrait is devoid of cuteness, and yet it has great "charm"—in the magical sense. It is only secondarily quaint, despite the inevitable, but thin, veneer of picturesqueness (totally aside from the subject matter; "exotic Native people") arising from the passage of historical time and the interval implied by the dress of almost ninety years ago. This is not, however, the Edward S. Curtis view of the Noble Savage, staring moodily into the misty past, or facing the camera forced upon him or her with the wariness and hostility that has been appropriated by the cliche of "dignity."

It is now common knowledge that one of the hegemonic devices of colonialism (postcolonialism is hardly free of it either) has been to isolate the Other in another time, a time that also becomes another place—The Past—even when the chronological time is the present. Like racism, this is a habit hard to kick even when it is recognized. Schaffer's photograph is a microcosmic triumph for social equality as expressed through representation. The discontinuity and disjunctiveness that usually characterize cross-cultural experience are translated here into a certain harmony—or the illusion thereof. This is a sympathetic photograph, but it is not, nor could it be, empathetic. (Is it possible honestly to perceive such a scene as idyllic, within the knowledge of such a dystopian social context?) The three figures, despite their smiles and amicable, knowing expressions, remain the objects of our eyes. We are simply lucky that this open, intelligent gaze has passed into history as evidence of a different encounter between Native and European, of the maintenance of some human interaction in the midst or aftermath of genocide.

The Beavers' portrait seems a classic visualization of what anthropologists call "intersubjective time." It commemorates a reciprocal moment (rather than a cannibalistic one) where the emphasis is on interaction and communication; a rare moment in which subject and object are caught in exchange within shared time. The enculturated distance between photographer and photographed, between white and Native, has

somehow been momentarily bridged to such an extent that the bridge extends over time to me, to us, almost a century later.

This is the kind of photograph I have often used as an example of the difference between images taken by someone from within a community and by an "outsider." I would have put it in the former category. However, it was not taken by a Stoney, but by an adventurous white lady passing through the Northern Rockies, possibly on that quest for self (or loss of self) in relation to Other and Nature which has been a major theme in North American culture.

The Beaver family (I wish I knew the woman's and child's names) is clearly among friends, but the picture might still have been very different if taken by a Native "insider." Of course we have no way of knowing what that image might have been. Photography, loaded with historical stigmas, has only recently become an accepted art form among Indian peoples; there are not many Native photographers working as "artists" even today. This has been explained from within the communities as a response to past abuses. Photography has been a tool by which to exploit and disarm, to document the "disappearance" of Indian nations, to keep them in their "place" in the past, and to make them objects of study and contemplation: "Government surveyors, priests, tourists, and white photographers were all yearning for the 'noble savage' dressed in full regalia, looking stoic and posing like Cybis statues. . . . We cannot identify with these images," wrote Flathead Jaune Quick-To-See-Smith, in her text for the first national Native American photography exhibition in 1984. The press release from the American Indian Community House Gallery in New York also set out some distinctions between non-Indian and these Indian photographers, among them: "These photos are not the universal images of Indians. They are not heroic, noble, stoic or romantic. What they do show is human warmth and an intimacy with their subject . . ." This is the feeling I get from the Beavers' portrait. Am I just kidding myself? Overidentifying with Mary Schaffer?

Another explanation for the avoidance of photography raises old taboos—the "photos-steal-your-spirit-syndrome," which is not, in fact, so far off in this situation. The more we know about representation the more obvious it becomes that photography is often a spirit snatcher. I "own" a postcard which permits me to have the Beaver family "living" in

my house. The Oglala warrior Crazy Horse never allowed his photograph to be taken, and it was said of those leaders who did that "they let their spirits be captured in a box" and lost the impetus to resistance. Contemporary American Indian Movement (AIM) leader Russell Means has described the introduction of writing into oral traditions as a destructive "abstraction over the spoken relationship of a people." The camera was another weapon in the wars of domination. As Dennis Grady observes:

> ... how fitting it must have seemed to the victims of that process—the natives of North America, whose idea of "vision" is as spiritual as it is physical—when the white man produced from his baggage a box that had the power to transcribe the world onto a flat paper plane. Here was a machine that could make of this landscape a surface; of this territory, a map; of this man, this woman, this living child, a framed, hand-held, negotiable object to be looked at, traded, possessed; the perfect tool for the work of the 'wasi'chu,' the greedy one who takes the fat.[2]

Our communal "memory" of Native people on this continent has been projected through the above-mentioned "stoic" (numb is a better term), wary, pained, resigned, belligerent and occasionally pathetic faces "shot" by nineteenth and early twentieth-century photographers like Edward Curtis, Edward Vroman, and Roland W. Reed—all men. Looking through a group of portraits of Indians from that period, I found one (*Indian with Feather Bonnet*, c. 1898) in which the expression was less grim, more eye-to-eye; the photographer was Gertrude Kasebier. The photographs by Kate Cory (a "midwestern spinster" who came to Arizona at age forty-four), taken in the Hopi village where she lived from 1905 to 1912, also diverge from the general pattern, as do some of Laura Gilpin's works.* All

* In 1989, Lily and Grant Berially, members of the Navajo Nation, won a suit against the Amon Carter Museum in Texas for the frequent public (and publicity) use of a Laura Gilpin photo called *Navajo Madonna*, taken in 1932. The court recognized that public use of a personal photo could be offensive and that the Navajos believe that "bad effects" could result from being photographed.—*The New Mexican,* June 10, 1989.

Lucy R. Lippard

of which suggests an empathetic relationship between race and gender lurking in this subject, although I can't explore it here.

Of course Mary Schaffer, although a woman and thereby also, divergently, disenfranchised, was at least indirectly allied with the oppressors. She may have been an "innocent" vehicle of her culture and her times. She may have been a rebel and independent of some of its crueler manifestations. Although it is more likely that she was oblivious to anthropological scholarship, she might have known about the then-new "comparative method," which was to permit the "equal" treatment of human culture in all times and in all places, but failed to overturn the edifice of Otherness built by previous disciplines. She may have been an enthusiastic perpetrator of expansionism.

Perhaps this photograph was already tinged with propaganda even at the time it was taken. Perhaps Mary Schaffer herself had an axe to grind. She may have been concerned to show her audience (and who were *they*?) that the only good Indian was not a dead Indian. Perhaps this portrait is the kind of "advocacy image" we find in the production of leftist photographers working in Nicaragua. The knowledgeable, sympathetic tourist is not always immune to cultural imperialism. I wonder if Mary Schaffer, like so many progressive photographers working in poorer neighborhoods and countries, gave her subjects a print of this photograph. Was it their first, their only image of themselves? Or the first that had not disappeared with the photographer? Is a curling copy of this picture given a place of honour in some family photo album or on the wall of some descendant's house?

I'm overpersonalizing the depicted encounter. To offset my emotional attraction to this image, let me imagine that Schaffer was a flag-waving imperialist, and try to read this image, or my responses to this image, in a mirror, as though I had taken an immediate dislike to it. Can I avoid that warm gaze and see in these three figures an illustration of all the colonial perfidy that provides its historical backdrop? Do Sampson Beaver and his family look helpless and victimized? They are handsome, healthy people; perhaps chosen to demonstrate that Indians were being "treated well." The family is seated on the ground, perhaps placed there because the photographer was influenced by stereotypical representa-

tions of the "primitive's" closeness to the earth, to nature. The woman is placed at a small distance from her husband and child, like a servant. They are smiling; perhaps Schaffer has offered the child a treat, or the adults some favor. Nevertheless, it is hard to see these smiles as solely money-bought.

A virtual class system exists among the common representations of an Indian family from this period: the lost, miserable, huddled group outside a teepee, the businesslike document of a neutrally "ordinary" family, or the proud, noble holdouts in a grand landscape, highlighted by giant trees or dramatic mesas. For all the separations inherent in such images, there is no such thing as "objectivity" or neutrality in portrait photography. Personal interaction of *some* kind is necessary to create the context within the larger frame of historical events. The Schaffer photo too is "posed." And the pose is an imposition since Native people had no traditional way of sitting for a portrait or a photograph; self-representation in that sense was not part of the cultures. But at least the Beaver family is not sitting bolt upright in wooden chairs; Sampson Beaver is not standing patriarchally with his hand on his wife's shoulder while the child is properly subdued below. Man and wife are comfortable and equal as they smile at the black box confronting them, and the little girl's expression is familiar to anyone who has spent time with little girls.

Today I received some scraps of information[3] about the Stoney Indians (an anglicization of the word Assine, meaning stone) who were Assiniboine, offshoots of the Sioux. They called themselves Nakodah and arrived in the foothills of the Rockies in the eighteenth century, fleeing smallpox epidemics. With the arrival of settlers and the founding of Banff, the Stoneys were forced into a life of relatively peaceful interaction with the townspeople. In the late nineteenth century, Banff was already a flourishing tourist town, boasting a spa and the annual "Indian Days" powwow, begun in 1889. The Whyte Museum there has a massive archive of photographs of the Native people of the Rockies (including this one, and one of Ginger Rogers on vacation, sketching Chief Jacob Twoyoungman in a plains headdress). Eventually forced to live off tourism, the Stoneys were exploited but not embattled. And Mary Schaffer, for all her credentials, was a tourist herself.

Indians were the photogenic turn-of-the-century counterparts of to-

Lucy R. Lippard

day's "lookouts"—roadside scenic vistas: ready-made "views," "nature" viewed from a static culture. The role of photography in tourism (or as tourism) started early. What looks to us today like a serious "documentary" photograph may just be the equivalent of *National Geographic* voyeurism, or a color print of a New York City homeless person taken for the folks at home. The "egalitarianism" (intentional or not) of Schaffer's photograph may have irritated her audience, at least those back East, where exaggeration and idealization of the "savage" reigned unchecked. Even today, when Indians wear rubber boots or sneakers at ceremonial dances, or an Apache puberty ritual includes six-packs of soda among the offerings, tourists and purists tend to be offended. Such "anachronisms" destroy the time-honoured distance between Them and Us, the illusion that They live in different times than We do. "Anachronisms" may also be somewhat threatening to Our peace of mind, recalling how They got "there," were put "there," in a space that is separated from us by the barbed wire of what has been called "absentee colonialism."

But how did *we* get There—off-center—to the places where we are face to face with those who do not apparently resemble us? Johannes Fabian distinguishes between historic religious travel "*to* the centers of religion or *to* the souls to be saved" and today's secular travel "*from* the centers of learning and power to places where man was to find nothing but himself."[4] The Sioux visionary Black Elk (like the Irish) says that anywhere can be the center of the world. We the "conquerors" have not thought so. We "travel" to the "margins" to fulfill some part of us that is "marginal" to our own culture, but is becoming increasingly, embarrassingly, central.

Once at the margins, we are not welcomed with open arms. At dances we gawk or smile shyly at the Indian people hurrying by, and they ignore us, or are politely aloof when spoken to, so long as we behave ourselves. They don't need us but we somehow, paradoxically, need them. We need to take images away from these encounters, to take Them with us. According to Dean McCannell, tourists are trying to "discover or reconstruct a cultural heritage or a social identity. . . . Sightseeing is a ritual performed to the differentiations of society."[5] The same might be said of photography itself. As the ultimate invasion of social, religious, and individual privacy, it is banned by many pueblos and reservations.

Last Take

The books I'd ordered from Banff finally arrived. I dove into them and of course had to revise some of my notions.

The Beaver family photography was taken in 1907, not 1906; not in early spring, but in late September, when Schaffer was completing a four-month expedition to the sources of the Saskatchewan River. Having just crossed two turbulent rivers, she and her companions reached the Golden Kootenai Plains (the Katoonda, or Windy Plains) and weaving in and out of yellowing poplars, they spied two tepees nestled deep among the trees.

> *I have seen not one but many of their camps and seldom or never have they failed to be artistic in their setting, and this one was no exception. Knowing they must be Silas Abraham's and Sampson Beaver's families, acquaintances of a year's standing, I could not resist a hurried call. The children spied us first, and tumbling head over heels, ran to cover like rabbits. . . . above the din and excitement I called, "Frances Louise!" She had been my little favourite when last we were among the Indians, accepting my advances with a sweet baby womanliness quite unlike the other children, for which I had rewarded her by presenting her with a doll I had constructed . . . love blinded the little mother's eyes to any imperfections, and the gift gave me a spot of my own in the memory of the forest baby. . . . In an instant her little face appeared at the tepee-flap, just as solemn, just as sweet, and just as dirty as ever.*[6]

It was this group of Stoneys (members of the Wesley Band) who the previous year had given Schaffer her Indian name—Yahe-Weha, Mountain Woman. Banned from hunting in the National Parks, they were still able to hunt, trap and live beyond their boundaries. In 1907 she remained with them for four days. "When I hear those 'who know' speak of the sullen, stupid Indian," she wrote:

> *I wish they could have been on hand the afternoon the white squaws visited the red ones with their cameras. There were no men to disturb the peace, the women quickly caught our ideas, entered the spirit of the*

Lucy R. Lippard

game, and with musical laughter and little giggles, allowed themselves
to be hauled about and posed and pushed in a fashion to turn an artist
green with envy ... Yahe-Weha might photograph to her heart's con-
tent. She had promised pictures the year before, she had kept the prom-
ise, and she might have as many photographs now as she wanted.[7]

Sampson Beaver's wife Leah was no doubt among the women that after-
noon. He was thirty years old at the time, and she looks around the same
age. In the language of the tourist, Schaffer described him crouching to
light his pipe at a campfire:

... his swarthy face lighted up by the bright glow, his brass earrings
and nail-studded belt catching the glare, with long black plaits of glossy
hair and his blanket breeches ...[8]

It was Sampson Beaver who then gave Schaffer one of the great gifts of
her life—a map of how to reach the legendary Maligne Lake which she
had hitherto sought unsuccessfully—thereby repaying his daughter's
friend many times over. He drew it from memory of a trip sixteen years
before—in symbols, "mountains, streams, and passes all included." In
1908 Schaffer, her friend Mollie Adams, "Chief" Warren (her young
guide, whom she later married), and "K" Unwin followed the accurate
map and became the first white people to document the shores of Cabha
Imne (Beaver Lake), ungratefully renamed Maligne for the dangerous
river it feeds. In 1911 she returned to survey the lake and its environs,
which lie in what is now Jasper National Park.

Mary Sharples Schaffer Warren (1861–1939) was not a Canadian but
a Philadelphian, from a wealthy Quaker family. Her father was a busi-
nessman and "gentleman farmer," as well as an avid mineralogist. She be-
came an amateur naturalist as a child and studied botany as a painter. In
1894 she married Dr. Charles Schaffer, a respected, and much older, doc-
tor whose passion was botany and with whom she worked as an illustra-
tor and photographer until his death in 1903. After completing and pub-
lishing his *Alpine Flora of the Canadian Rocky Mountains*, she conquered
her fear of horses, bears, and the wilderness, and began her lengthy ex-

ploring expeditions, going on horseback with pack train deep into the then mostly uncharted wilderness for months at a time.

Schaffer's interest in Indians and the West had been awakened when, as a small child, she overheard her Cousin Jim, an army officer, telling her parents about the destruction of an Indian village in which women and children were massacred; afterwards he had found a live baby sheltered by the mother's dead body. This story made a profound impression on Mary Schaffer, and she became obsessed with Indians. In her mid-teens she took her first trip west, met Native people for the first time, and became an inveterate traveller. The Canadian Rockies were her husband's botanical turf, and for the rest of her life Schaffer spent summers on the trails, photographing, writing and exploring. She finally moved to Banff, where she died.

When Schaffer and Mollie Adams decided to take their plunge into the wilderness, it was unprecedented, and improper, for women to encroach on this steadfastly male territory. However, as Schaffer recalled:

> ... there are times when the horizon seems restricted, and we seemed to have reached that horizon, and the limit of all endurance—to sit with folded hands and listen calmly to the stories of the hills we so longed to see, the hills which had lured and beckoned us for years before this long list of men had ever set foot in the country. Our cup splashed over. We looked into each other's eyes and said: "Why not? We can starve as well as they; the muskeg will be no softer for us than for them ... the waters no deeper to swim, nor the bath colder if we fall in,"—so—we planned a trip.[9]

These, and many other hardships and exhilarations, they did endure, loving almost every minute of it, and documenting their experiences with their (often ineptly hand-colored) photographs of giant peaks, vast rivers, glaciers, and fields of wildflowers. When they were returning from the 1907 expedition, they passed a stranger on the trail near Lake Louise who wrote:

> As we drove along the narrow hill road a piebald pack-pony with a china-blue eye came round a bend, followed by two women, black

Lucy R. Lippard

haired, bare-headed, wearing beadwork squaw jackets and riding straddle. A string of pack-ponies trotted through the pines behind them.

"Indians on the move?" said I. "How characteristic!" As the women jolted by, one of them very slightly turned her eyes and they were, past any doubt, the comprehending equal eyes of the civilised white woman which moved in that berry-brown face....

The same evening, in a hotel of all the luxuries, a slight woman in a very pretty evening frock was turning over photographs, and the eyes beneath the strictly arranged hair were the eyes of the woman in the beadwork who had quirted the piebald pack-pony past our buggy.[10]

The author of this "photographic" colonial encounter was, ironically, Rudyard Kipling.

As Levi-Strauss has pointed out, the notion of travel is thoroughly corrupted by power. Mary Schaffer, for all her love of the wilderness (which she constantly called her "playground") was not free from the sense of power that came with being a prosperous "modern" person at "play" in the fields of the conquered. At the same time, she also expressed a very "modern" sense of melancholy and loss as she watched the railroad (which she called a "python") and ensuing "civilization" inching its way into her beloved landscape. More than her photographs, her journals betray a colonial lens. She is condescendingly "fond," but not very respectful, of the "savages" who are often her friends, bemoaning their unpleasantly crude and hard traditional life. In 1911, for instance, her party passed "a Cree village where, when we tried to photograph the untidy spot, the inhabitants scuttled like rabbits to their holes." In 1907, on the same "golden" Kootenai Plains where she took the Beavers' portrait, their camp was visited by "old Paul Beaver," presumably a relative of her darling Frances Louise. He eyed their simmering supper "greedily," but

our provisions were reaching that point where it was dangerous to invite any guests, especially Indians, to a meal, so we downed all hospitable inclinations and without a qualm watched him ride away on his handsome buckskin just as darkness was falling.[11]

Despite years of critical analysis, seeing is still believing to some extent—as those who control the dominant culture (and those who ban it

from Native contexts) know all too well. In works like this one, some of the barriers are down, or invisible, and we have the illusion of seeing for ourselves, the way we never *would* see for ourselves, which is what communication is about. For all its socially enforced static quality, and for all I've read into it, Mary Schaffer's photograph of Sampson, Leah, and Frances Louise Beaver is "merely" the image of an ephemeral moment. I am first and foremost touched by its peace and freshness. I can feel the ground and grass warm and damp beneath the people sitting "here" in an Indian Summer after disaster had struck, but before almost all was lost. As viewers of this image, eighty-four years later, on the verge of the quincentennial of Columbus' accidental invasion of the Americas, we can only relate our responses in terms of what we know. And as a nation we don't know enough.

Thanks to Gerald McMaster and Jon Whyte.

Notes

1. Johannes Fabian, *Time and the Other: How Anthropology Makes Its Object* (New York: Columbia University Press, 1983).
2. Dennis Grady, "The Devolutionary Image: Toward a Photography of Liberation," *SF Camerawork* 16 (Summer/Fall 1989), p. 28.
3. Jon Whyte, *Indians in the Rockies* (Banff: Altitude Publishing Ltd., 1985).
4. Fabian, *Time and the Other.*
5. Dean MacCannell, *The Tourist: A New Theory of the Leisure Class* (New York: Schocken Books, 1989).
6. E. J. Hart, ed., *Hunter of Peace: Mary T. S. Schaffer's Old Indian Trails of the Canadian Rockies* (Banff: Whyte Museum, 1980), p. 70.
7. Hart, *Hunter of Peace*, p. 71.
8. Ibid., p. 72.
9. Ibid., p. 17.
10. Ibid., p. 69.
11. Ibid.

Arthur C. Danto

Art and the Discourse of Nations

Now that the central dispute concerning the National Endowment for
the Arts has passed from the issue of moral sensibilities of the taxpayer
and the artistic rights of free expression and how these are to be recon-
ciled, to the issue of whether there is any justification for the artistically
indifferent taxpayer to sustain what those hostile to the arts do not hesi-
tate to stigmatize as an elitist preoccupation, those of us who favor the
continued existence of the endowment have had to cast about for argu-
ments to show how central to the political health of the nation art is,
however attenuated the interest in art of the average taxpayer may be.
For example, I was struck by the almost universal excitement aroused by
the newly discovered cave paintings in the Ardèche a few months ago,
said to have been painted twenty thousand years ago. Whether neolithic
culture had a concept of art, the production of these vital images of charg-
ing animals had to have had a profound meaning for that society as a
whole. It clearly could not have been an elitist distraction to paint and to
appreciate these images, and since artmaking, however conceptualized,
seemed to spring spontaneously from human beings whose genetic en-
dowment was in every respect the same as our own, it must lie very close
to whatever is distinctively human, as much so as our power of language.
There are more than two hundred known caves with paintings in them,

representing something like an Ice Age high culture, and it is at least thinkable that many of these were independent of the others, so that the same impulses arose spontaneously wherever there were people. It is similarly thinkable that images were affixed to surfaces which did not have the lasting power of the cave walls—to bark, skin, bone. Anything that inherent in the human essence grounds a right, indeed a human entitlement, as compelling as the other rights a government exists to guarantee—health, education, security—and hence, it seems to me, an internal connection between this remarkable trait of human nature and a governmental responsiveness may be asserted, which has nothing to do with the division of society into elites and non-elites. To be human is to have a natural, indeed an inalienable interest in art, whether or not one does anything about it—just as people have a right to healthy lives even if as individuals they neglect their physical well-being in innumerable ways.

I have very little expectation that this argument, which I developed as an editorial for *The Nation*, is going to elicit a reprieve from the budget-cutters who foresee an easy lop in the National Endowment for the Arts, but possibly it may temper the rhetoric with which they seek to score points with a supposedly unaffected electorate—the very people, in fact, who were charmed and amazed by the Ardèche bears and horses. Beyond that, the need to seek arguments which connect the existence of art with practices that imply certain very deep human beliefs and attitudes is one of the indirect benefits of what on the surface seems to be a conflict in the responsibilities of government. I think, even for those of us close to art, who produce and write about art, who take for granted the institutions within which producing and writing about art are enabled, it is rare that we rise to a level of reflective self-consciousness on the nature of what we are doing. And having to defend ourselves from charges of social irrelevance forces us to think a little more deeply than we otherwise might. So let me draw attention to a couple of seemingly marginal matters that might help us think of what art means in the larger political life of the world's states.

About a year ago, there was a message on my voice-mail at Columbia from someone in Johannesburg, asking me to write a catalog essay for the First Johannesburg Biennale, to be held February 1995, details to follow.

As it happens, the Venice Biennale is a hundred years old this year, and I enjoyed the idea that having written an essay for the oldest of the biennales in 1993, I might write one for the newest, so of course I accepted. The exhibition in Venice for which my essay was written was called *Punti Cardinale dell'Arte*—the cardinal points of art—and it was a kind of compass of world art, featuring major artists, sixteen in all, from sixteen cardinal points of the world of art. Johannesburg was not on that map in 1993, largely, I suppose, because, in the view of the show's organizer, there was not an artist there of the magnitude of those included in this exhibition, but 1993 was the first year South Africa was represented in the great exhibition since apartheid was first established as a national policy. Coming almost immediately on the heels of the elections that brought Nelson Mandela to the presidency, the Johannesburg Biennale was a declaration on the part of the responsible agencies that South Africa belonged once again to the world in which artists could be invited to show their work and critics invited to write catalog essays, that a country despised for its politics had claimed standing in the commonwealth of civilized powers, and this claim was accepted in people's acceptance of the invitations. Moreover, it all at once came home to me that the art exhibition had taken on the meaning of a language of recognition and reconciliation. When the German nation put on the exhibition Documenta in Kassel in the late 1940s, it demonstrated that it wished to acknowledge its readiness to participate once again in civilized discourse. And in people's participation in that exhibition, the gesture itself was acknowledged. After World War II, Austria and Japan sent exhibitions of reconciliation to America as a sign that hostilities were over. When detente set in in the 1980s, there was no better sign of this reconciliation than the exchange of exhibitions of impressionist and postimpressionist paintings between the then Soviet Union and the United States.

I think this is the bright side of something found deep in ancient human practices; namely, that victors declare their power by taking the art of the defeated as trophies, which is a kind of cultural rape. To rob a society of its art is symbolically equivalent to violating its women, a way of destroying its seed and humiliating it totally. Agamemnon took the gold of Priam from Troy to Mycenae; in turn this booty was, in the last war, carried off by Russians from the defeated Germans. The Germans under

Hitler and Goering did the same, as did Napoleon, to whose wholesale confiscation of art we owe the museums of Europe: as temples for the display of artistic trophies from defeated nations—or, in the case of the Altes Museum in Prussia, as a temple for art treasures reclaimed. It is possible to argue that by *not*, at least not officially, engaging in that practice, the United States has behaved consistently with the senatorial rhetoric that art is so much frill. But the entire testimony of international practice, on both its dark and bright sides—on the side of humiliation by taking an enemy's treasures, and on the side of establishing exchanges of treasures in the confidence that they will not be taken hostage—stands opposed to this pretended indifference. Art is a language in which nations convey so much to one another that one has to ask how they would do this if art did not exist. Then too the question arises of what it is in the nature of art that enables it to play this extraordinary symbolic function.

My sense is that to answer this question we must go back to the caves of Lascaux and the Ardèche. While I would not expect this exploration to sway minds on the future of the endowment, I would argue that something as deeply embedded in the meaning of victory, defeat, recognition, and acknowledgment as art is cannot seriously be stigmatized as of concern only to elites. The Swedish troops who bore off the prizes of Prince Rudolph's collection in Prague and the Aztec king who sent examples of the art of his culture to Charles V—a king he had never heard of in a country he would not have known about had his own land not been invaded—understood the meaning of art. As did the Parisian populace that crowded into the galleries of the Louvre to see the art that had become theirs by overthrowing the king whose power was defined through that art. As do the artists from the compass points of the world of art who converged on Johannesburg as a symbolic handshake of moral acceptance.

I want to conclude with an observation based on a contrast between the art of the First Johannesburg Biennale and the trophaeal art that almost concurrently went on display at the Hermitage Museum in Saint Petersburg—art the Russian troops had taken away from a Germany defeated as an emblem of that defeat. These belong respectively to the bright and the dark side of art as moral currency, a distinction unaffected, a distinction perhaps even underscored, by the fact that none of the art sent to Johannesburg was in the nature of treasures that might in some

future war be candidates for trophies. The most interesting art of our time is nothing it would occur to anyone to steal, and I think it a matter of tremendous significance that art and what I might call tresoriousness have gone in different directions. Moctezuma felt that only gold was a suitable medium to convey the advancement of his culture, as did King Priam. Media today can be videotape, plywood, newspaper, discarded garments, industrial paint, shattered glass, or bodily gestures. The magic is unaffected by the detresorification of art, and the mystery of its acknowledged significance remains. In some respect too hidden for me to say anything further about it, it is connected with what it means to be human, and I salute you new graduates of the School of Visual Arts for your dedication to this profoundly human calling. It has been a privilege to be your speaker as you cross the line into a practice whose meaning is as momentous as its absence would be unthinkable in the lives of peoples and nations. I know of no philosophical theory of art that explains its evident importance, and I leave this as a problem to ponder as well as a pennant to flourish when you are challenged to defend your choice of lives.

bell hooks

Art Is for Everybody

In high school I painted pictures that won prizes. My art teacher, a white man whom we called Mr. Harold, always promoted and encouraged my work. I can still remember him praising me in front of my parents. To them art was play. It was not something real—not a way to make a living. To them I was not a talented artist because I could not draw the kind of pictures that I would now call documentary portraits. The images I painted never looked like our familiar world and therefore I could not be an artist. And even though Mr. Harold told me I was an artist, I really could not believe him. I had been taught to believe that no white person in this newly desegregated high school knew anything about what black people's real lives were all about. After all, they did not even want to teach us. How, then, could we trust what they taught? It did not matter that Mr. Harold was different. It did not matter to grown folks that in his art classes he treated black students like we had a right to be there, deserved his attention and his affirmation. It did not matter to them, but it began to matter to *us:* We ran to his classes. We escaped there. We entered the world of color, the free world of art. And in that world we were, momentarily, whatever we wanted to be. That was my initiation. I longed to be an artist, but whenever I hinted that I might be an artist, grown folks looked at me with contempt. They told me I had to be out of my mind

96

thinking that black folks could be artists—why, you could not eat art. Nothing folks said changed my longing to enter the world of art and be free.

Life taught me that being an artist was dangerous. The one grown black person I met who made art lived in a Chicago basement. A distant relative of my father's, cousin Schuyler was talked about as someone who had wasted his life dreaming about art. He was lonely, sad, and broke. At least that was how folks saw him. I do not know how he saw himself, only that he loved art. He loved to talk about it. And there in the dark shadows of his basement world he initiated me into critical thinking about art and culture. Cousin Schuyler talked to me about art in a grown-up way. He said he knew I had "the feeling" for art. And he chose me to be his witness: to be the one who would always remember the images. He painted pictures of naked black women, with full breasts, red lips, and big hips. Long before Paul Gauguin's images of big-boned naked brown women found a place in my visual universe, I had been taught to hold such images close, to look at art and think about it, to keep art on my mind.

Now when I think about the politics of seeing—how we perceive the visual, how we write and talk about it—I understand that the perspective from which we approach art is overdetermined by location. I tell my sister G., who is married to a man who works in an auto factory in Flint, Michigan, and has three children, that I am thinking about art. I want to know whether she thinks about art, and, more importantly, if she thinks most black folks are thinking about art. She tells me that art is just too far away from our lives, that "art is something—in order to enjoy and know it, it takes work." And I say, "But art is on my mind. It has always been on my mind." She says, "Girl, you are different, you always were into this stuff. It's like you just learned it somehow. And if you are not taught how to know art, it's something you learn on your own."

We finish our late-night conversation and it's hours later when, staring into the dark, art on my mind, I remember Mr. Harold. I close my eyes and see him looking over my work, smell him, see the flakes of dandruff resting on his black shirt. In the dark, I conjure an image of him: always in black, always smiling, willing to touch our black hands while the other white folks hate and fear contact with our bodies. In the dark of

memory, I also remember cousin Schuyler, the hours of listening and talking about art in his basement, the paintings of naked brown women. And I think Sister G. is wrong. I did not just learn to think about art on my own—there were always teachers who saw me looking, searching the visual for answers, and who guided my search. The mystery is only why I wanted to look while others around me closed their eyes—that I cannot yet explain.

When I think of the place of the visual in black life, I think most black folks are more influenced by television and movie images than by visual arts like painting, sculpture, and so on. My sister G. told me: "We can identify with movies and we don't feel we know how to identify with art." Black folks may not identify with art due to an absence of representation. Many of us do not know that black folks create diverse art, and we may not see them doing it, especially if we live in working-class or underclass households. Or art (both the product and the process of creation) may be so devalued—not just in underclass communities, but in diverse black contexts, and, to some extent, in our society as a whole—that we may deem art irrelevant even if it is abundantly in our midst. That possibility aside, the point is that most black folks do not believe that the presence of art in our lives is essential to our collective well-being. Indeed, with respect to black political life, in black liberation struggles— whether early protests against white supremacy and racism during slavery and Reconstruction, during the civil rights movement, or during the more recent black power movements—the production of art and the creation of a politics of the visual that would not only affirm artists but also see the development of an aesthetics of viewing as central to claiming subjectivity have been consistently devalued. Taking our cues from mainstream white culture, black folks have tended to see art as completely unimportant in the struggle for survival. Art as propaganda was and is acceptable, but not art that was concerned with any old subject, content, or form. And black folks who thought there could be some art for art's sake for black people, well, they were seen as being out of the loop, apolitical. Hence, black leaders have rarely included in their visions of black liberation the necessity to affirm in a sustained manner creative expression and freedom in the visual arts. Much of our political focus on the visual has been related to the issue of good and bad images. Indeed,

many folks think the problem of black identification with art is simply the problem of underrepresentation, not enough images, not enough visible black artists, not enough prestigious galleries showing their work.

Representation is a crucial location of struggle for any exploited and oppressed people asserting subjectivity and decolonization of the mind. Without a doubt, if all black children were daily growing up in environments where they learned the importance of art and saw artists that were black, our collective black experience of art would be transformed. However, we know that, in the segregated world of recent African-American history, for years black folks created and displayed their art in segregated black communities, and this effort was not enough to make an intervention that revolutionized our collective experience of art. Remembering this fact helps us to understand that the question of identifying with art goes beyond the issue of representation.

We must look, therefore, at other factors that render art meaningless in the everyday lives of most black folks. Identification with art is a process, one that involves a number of different factors. Two central factors that help us to understand black folks' collective response to art in the United States are, first, recognition of the familiar—that is, we see in art something that resembles what we know—and, second, that we look with the received understanding that art is necessarily a terrain of defamiliarization: it may take what we see/know and make us look at it in a new way.

In the past, particularly in segregated school settings, the attitude toward art was that it had a primary value only when it documented the world as is. Hence the heavy-handed emphasis on portraiture in black life that continues to the present day, especially evident if we look at the type of art that trickles down to the masses of black folks. Rooted in the African-American historical relation to the visual is a resistance to the idea of art as a space of defamiliarization. Coming to art in search only of exact renderings of reality, many black folks have left art dissatisfied. However, as a process, defamiliarization takes us away from the real only to bring us back to it in a new way. It enables the viewer to experience what the critic Michael Benedikt calls in his manifesto *For an Architecture of Reality* "direct esthetic experiences of the real." For more black folks to identify with art, we must shift conventional ways of thinking about the

function of art. There must be a revolution in the way we see, the way we look.

Such a revolution would necessarily begin with diverse programs of critical education that would stimulate collective awareness that the creation and public sharing of art is essential to any practice of freedom. If black folks are collectively to affirm our subjectivity in resistance, as we struggle against forces of domination and move toward the invention of the decolonized self, we must set our imaginations free. Acknowledging that we have been and are colonized both in our minds and in our imaginations, we begin to understand the need for promoting and celebrating creative expression.

The painter Charles White, commenting on his philosophy of art, acknowledged: "The substance of man is such that he has to satisfy the needs of life with all his senses. His very being cries out for these senses to appropriate the true riches of life: the beauty of human relationships and dignity, of nature and art, realized in striding towards a bright tomorrow.... Without culture, without creative art, inspiring to these senses, mankind stumbles in a chasm of despair and pessimism." While employing sexist language, White was voicing his artistic understanding that aesthetics nurture the spirit and provide ways of rethinking and healing psychic wounds inflicted by assault from the forces of imperialist, racist, and sexist domination.

As black artists have broken free from imperialist white-supremacist notions of the way art should look and function in society, they have approached representation as a location for contestation. In looking back at the lives of Lois Mailou Jones and Romare Bearden, it is significant to note that they both began their painting careers working with standard European notions of content and form. Their attempt to assimilate the prevailing artistic norms of their day was part of the struggle to gain acceptance and recognition. Yet it was when they began to grapple within their work with notions of what is worthy of representation—when they no longer focused exclusively on European traditions and drew upon the cultural legacy of the African-American diasporic experience—that they fully discovered their artistic identity.

Lois Mailou Jones has said that it was an encounter with the critic Alain Locke that motivated her to do work that directly reflected black

experience. Locke insisted that black artists had to do more with the black experience and, especially, with their heritage. Although Romare Bearden was critical of Locke and felt that it was a mistake for black folks to think that all black art had to be protest art, Bearden was obsessed with his ancestral legacy, with the personal politics of African-American identity and relationships. This subject matter was the groundwork that fueled all his art. He drew on memories of black life—the images, the culture.

For many black folks, seeing Romare Bearden's work redeems images from our lives that many of us have previously responded to only with feelings of shame and embarrassment. When Bearden painted images reflecting aspects of black life that emerged from underclass experience, some black viewers were disturbed. After his work appeared in a 1940s exhibition titled "Contemporary Negro Art," Bearden wrote a letter to a friend complaining about the lack of a sophisticated critical approach to art created by black folks. "To many of my own people, I learn, my work was very disgusting and morbid—and portrayed a type of Negro that they were trying to get away from." These black audiences were wanting art to be solely a vehicle for displaying the race at its best. It is this notion of the function of art, coupled with the idea that all black art must be protest art, that has served to stifle and repress black artistic expression. Both notions of the function of art rely on the idea that there should be no non-representational black art. Bearden's work challenged the idea that abstraction had no place in the world of black art. He did not accept that there was any tension between the use of black content and the exploration of diverse forms. In 1959 Bearden wrote, "I am, naturally, very interested in form and structure—in a personal way of expression which can perhaps be called new. I have nothing, of course, against representational images, but the demands, the direction of the sign factors in my painting now completely obliterate any representational image."

Although Bearden was a celebrated artist when he died in 1988, his work has reached many more black folks since his death. Those black audiences who have learned to recognize the value of black artistic expression revere Bearden for his having dared to make use of every image of black life available to his creative imagination. As so much traditional black folk experience is lost and forgotten, as we lose sight of the rich ex-

perience of working-class black people in our transnational corporate society, many of us are looking to art to recover and claim a relationship to an African-American past in images.

The writer Ntozake Shange offers testimony similar to Wilson's in *Ridin' the Moon in Texas*. In a "note to the reader" at the beginning of the book, she shares the place of art in her life. Talking first about growing up with a father who painted, who had a darkroom, she continues: "As I grew I surrounded myself with images, abstractions that drew warmth from me or wrapped me in loveliness. . . . Paintings and poems are moments, capturing or seducing us, when we are so vulnerable. These images are metaphors. This is my life, how I see and, therefore, am able to speak. Praise the spirits and the stars that there are others among us who allow us visions that we may converse with one another."

Revealing to the reader her privileged background in this note, Ntozake evokes a domestic black world in which art had a powerful presence, one that empowered her to expand her consciousness and create. While writing this piece, I have spoken with many black folks from materially privileged backgrounds who learned in their home life to think about art and sometimes to appreciate it. Other black folks I have talked with who have access to money mention seeing black art on the walls while watching *The Cosby Show* and developing an interest. They speak about wanting to own black art as an investment, but they do not speak of an encounter with the visual that transforms. Though they may appreciate black art as a commodity, they may be as unable to identify with art aesthetically as are those who have no relation at all to art.

I began this essay sharing bits and pieces of a conversation that did not emerge from a bourgeois standpoint. My sister G. considered the role of art in black life by looking critically at the experiences of black working-class, underclass, and lower-middle-class folks in the world she has known most intimately. Looking at black life from that angle, from those class locations that reflect the positionality of most black folks, she made relevant observations. We both agreed that art does not have much of a place in black life, especially the work of black artists.

Years ago most black people grew up in houses where art, if it was present at all, took the form of cheap reproductions of work created by white artists featuring white images; some of it was so-called great art.

bell hooks

Often these images incorporated religious iconography and symbols. I first saw cheap reproductions of art by Michelangelo and Leonardo da Vinci in Southern black religious households. We identified with these images. They appealed to us because they conveyed aspects of religious experience that were familiar. The fact of whiteness was subsumed by the spiritual expression in the work.

Contemporary critiques of black engagement with white images that see this engagement solely as an expression of internalized racism have led many folks to remove such images from their walls. Rarely, however, have they been replaced by the work of black artists. Without a radical counterhegemonic politics of the visual that works to validate black folks' ability to appreciate art by white folks or any other group without reproducing racist colonization, black folks are further deprived of access to art, and our experience of the visual in art is deeply diminished. In contemporary times, television and cinema may be fast destroying any faint desire that black folks might have, particularly those of us who are not materially privileged, to identify with art, to nurture and sustain our engagement with it as creators and consumers.

Our capacity to value art is severely corrupted and perverted by a politics of the visual that suggests we must limit our responses to the narrow confines of a debate over good versus bad images. How can we truly see, experience, and appreciate all that may be present in any work of art if our only concern is whether it shows us a positive or negative image? In the valuable essay "Negative/Positive," which introduces Michele Wallace's collection *Invisibility Blues*, Wallace cautions us to remember that the binary opposition of negative versus positive images too often sets the limits of African-American cultural criticism. I would add that it often sets the limits of African-American creative practice, particularly in the visual arts. Wallace emphasizes that this opposition ties "Afro-American cultural production to racist ideology in a way that makes the failure to alter it inevitable." Clearly, it is only as we move away from the tendency to define ourselves in reaction to white racism that we are able to move toward that practice of freedom which requires us first to decolonize our minds. We can liberate ourselves and others only by forging in resistance identities that transcend narrowly defined limits.

Art constitutes one of the rare locations where acts of transcendence

can take place and have a wide-ranging transformative impact. Indeed, mainstream white art circles are acted upon in radical ways by the work of black artists. It is part of the contemporary tragedy of racism and white supremacy that white folks often have greater access to the work of black artists and to the critical apparatus that allows for understanding and appreciation of the work. Current commodification of blackness may mean that the white folks who walk through the exhibits of work by such artists as Bettye and Alison Saar are able to be more in touch with this work than most black folks. These circumstances will change only as African-Americans and our allies renew the progressive black liberation struggle—reenvisioning black revolution in such a way that we create collective awareness of the radical place that art occupies within the freedom struggle and of the way in which experiencing art can enhance our understanding of what it means to live as free subjects in an unfree world.

bell hooks

Y

The Art Critic

I admit I spend most of my day looking out my window. I look down at the intersection where Christopher and Ninth Streets meet Sixth and Greenwich Avenues. I watch people crisscrossing all day, men selling books, an occasional bride and groom in the garden of the Jefferson Market Library. And at the center, the Ruth Wittenberg Triangle, named for the "ardent Greenwich Villager" and "courageous leader." Worlds converge there. It seems as powerful as a great pyramid. Nothing can disturb its controlled chaos.

Then, a few months ago, a truck pulled up and a Y-shaped object was lowered onto the cement triangle. It was about ten feet tall and wrapped in plastic. For the rest of the day, people picked at the plastic and the next morning it stood entirely exposed. A big metal Y painted hot pink with the word "discriminate" in block letters down its stem on both sides. Y. Discriminate. Y. Discriminate. Oh, I finally got it: Why discriminate?!

"Why hot pink?" I wondered as I stared in horror. "Why here? Why now, during my one-year lease?" I called my friend David, who lives nearby. "Did you see it?" I asked. "I saw it," he said glumly.

Beneath the big pink Y is a plaque with the following inscription: "Why, do we live so comfortably with an imbalance of inequality and irresponsibility?" It is signed by the artist, Ralph G. Brancaccio.

I read it over and over. It didn't even make sense. Why the comma after the word "why"? Why the strange sentence structure?

With perverse pleasure, I noticed a small patch of gold graffiti had already appeared on the Y's lengthy torso, like a rash. I wished it would spread.

The next day, I watched from my window as people stopped at the Y. They touched it and patted it, leaned against it, imitated it with their arms—forming human Y's like the Village People—read the inscription with confused looks on their faces and posed with it for photographs. Children ran around it. An old man with a gnarled walking stick meditated in front of it. It interrupted the flow. I sat paralyzed, unable to work. I hated the Y.

Suddenly a large crowd gathered around it. Thinking it must be a protest, I rushed downstairs. "Welcome to the unveiling," a gallery-type girl said. She handed me an artist statement littered with typos. "He's here," she said, excitedly, pointing to a good-looking young man in a white T-shirt and pin-striped suit. People surrounded him.

"I'm a reporter for Details magazine," I lied. "Why did you put this thing here?"

"I just hate discrimination," he said. "I have twenty more Y's planned. You know, Y. Starvation, Y. Poverty, Y. War, et cetera."

"It's too bad about that," I said, pointing to the graffiti.

That night I watched with binoculars as the artist stood in the pouring rain in a hunter green, hooded rain slicker gently scrubbing at the Y with Q-tips.

The second he left, I grabbed my umbrella and ran across the street to the Y. I stood alone, unwrapping cube after cube of Bubble Yum and chewing furiously. I placed the large wads artistically on all four sides of it. A police car circled but I didn't care. I'd go to jail if I had to.

The following evening David and I found ourselves in the children's story-telling room at the library. The artist was giving a "talk."

"I don't like the color," an old woman said. "The paint was donated," the artist said. "I didn't choose it."

"The inscription doesn't make sense," another old woman said.

They were the only two people there besides David and me.

"That's due to a mistake by the engraver," the artist said.

A mistake? Would Michelangelo allow his statue to be called Donald instead of David if the engraver had been sloppy?

"It's not art—it's advertising," the first old woman said. "And it's covered in gum."

"I didn't come here to listen to you," the second woman said to the first as she stormed out of the meeting.

"I have to say, I sort of like him," David said, afterwards. "He's good-looking."

I had to agree. "But I still hate it," I added.

For months I brooded about the Y. I discussed it in therapy. I ranted to friends. I considered chaining my bicycle to it, or even myself, as I imagined Ruth Wittenberg might have done. I started noticing other public art, as if for the first time. Why couldn't I have the cute bronze creatures in Hudson River Park instead of my Y? I was really beginning to wonder about myself. And then something strange happened.

I stopped noticing. The Y stood there tall and proud, but I had stopped discriminating against it. I didn't even see the men come to take it away.

David called and invited me to a movie.

"I'll meet you at the Y," I said.

Dave Hickey

Frivolity and Unction

The darker side of channel surfing: I was ensconced in a motel in the heartland on a Sunday evening. Abandoned by my keepers at the local university, I was propped up on the bed, eating a burrito and swooping through the channels when I realized that I had just flipped past a rather bizarre primetime option. Reversing my board into the curl, I flipped back a couple of channels, and, by jiminy, there it was: the auction room at Sotheby's, in the teaser for *60 Minutes*. I was teased, naturally, so I "stayed tuned" for what turned out to be a televised essay on the fatuity and pretentiousness of the art world. Morley Safer played Gulliver in this essay. Various art personalities appeared in the role of Houyhnhnms. I just sat there frozen, like a deer in the headlights. Then I caught the drift, relaxed, and tried to get into it. No one was being savaged about whom I cared that much. Nothing very shocking was being revealed. It was just the same old fatuous, pretentious art world, and nothing confirms me more strongly in my choice of professions than a good healthy dose of sturdy, know-nothing, middle-American outrage at the caprices of this world.

Over the years, I have become something of a connoisseur of mid-cult portrayals of the art world. Among my favorites are the six or seven "art episodes" of *Perry Mason*, with their egregious fakes and heartless

frauds, their felonious art dealers, patronizing critics, vain artists, and gullible collectors. I also keep a warm place in my heart for Waldo Lydecker, the psychopathic art critic and connoisseur played by Clifton Webb in *Laura*. For a kid like me, stranded out in the big bland, beguiled by glamour and hungry for some stylish action, the image of the effete Waldo in his posh Manhattan digs, reclining in his perfumed bath, shattering someone's reputation with a whisk of his poison pen, was a deftly alluring one—and remains so, in fact.

No more alluring, however, than the rough, improvisational world that I inferred from Luce Publications' sneering coverage of Jackson Pollock's unruly triumph and Andy Warhol's apocalyptic opening at the Institute of Contemporary Art in Philadelphia—where they took down the paintings to make room for the party. For myself, and for many of my friends, these news magazine stories provided our first fleeting glimpse of something other—of something braver and stranger. We recognized the smirky, condescending tone of these stories, but kids are expert in decoding this tone, which invariably means: This may look like fun, but don't do it. But it still looked like fun, and thus, far from retarding the progress of peculiar art and eccentric behavior, poor Hank Luce inadvertently propagated it, seeding the heartland with rugged little paint-splashers and frail, alien children with silver hair.

The world portrayed in Morley Safer's essay on *60 Minutes* did not look like fun. No matter how artfully decoded, the piece was not going to lure any children out of the roller-rink in Las Cruces. It was obsessed with money, virtue, and class-hatred—issues ill-designed to put your thumb out in the wind. Safer's piece did, however, fulfill the conditions of satire: It was unrepresentative, ungenerous, and ruthlessly unfair—but it was not wrong. It was wrong-headed, ignorant, and ill-informed about art, as well, but if these afflictions disqualified folks from commentary, more than half of the art community itself would be stricken mute. So I was cool with Safer's jibes. It's a free country and all like that, and who the hell watches *60 Minutes*, anyway, unless they're stranded in a motel out by the highway in the middle of America?

Also, Safer's piece did present some possibilities. It was not going to lure any loonies out of the woodwork, but what a *delicious* straight man Safer was!—what an exquisite target for dazzling *repartie*, for manifesta-

tions of *élan*, demonstrations of *panache*, and other French attitudinal stratagems that might constitute a lively and confident response to Morley's mid-cult unction. "Morley who?" "Sixty what?" "You watch TV on Sunday night?" "Don't you have any *friends!?*" Even rudimentary dish like this would have been welcome, but it never materialized. In fact, a great many of my colleagues just lost it. What seemed routinely unfair to me was construed by them as cruelly *unjust!*—and this "injustice" was quickly transformed into "oppression," conjuring up, once again, the fascist heel, stomping down upon the frail ladybug of "the art community."

In the following weeks, people who should have known better filled the air with self-righteous bleats of indignation and defense—no easy task since one could hardly attack Safer without seeming to defend the perspicacity of West Side collectors, the altruism of Sotheby's auctions, and the *gravitas* of Christopher Wool. Even so, the art world just capitulated. Far from exhibiting magisterial disdain, the director of a major American museum even appeared with Safer on *The Charlie Rose Show*. Challenged by Safer with the undeniable fact that contemporary art lacks "emotive content," this director of a major museum insisted, in effect, that "It does *too* have emotive content!" confessing that he, personally, had burst into tears upon entering Jenny Holzer's installation at the Venice Biennale. *Well, didn't we all*, I thought (there being tears and tears), and at that moment, had there been an available window or website at which I could have resigned from the art world, I should certainly have done so.

I couldn't believe it. Within the year, I had seen similar and even more acerbic pieces on the music business and the film industry in primetime, and the members of *these* communities had somehow managed to maintain their composure—had kept their wits about them and simply refused to credit the Church Lady standards to which they were being held accountable. None of my colleagues (excepting the redoubtable Schjeldahl) quite rose to this challenge, and it occurred to me that their pedantic squeal was not dissimilar to the aggrieved hysteria with which the French Academy responded to the father of my profession, La Font de Saint-Yenne, when he published the first *Salon* in 1737—a tract that is no less entertaining, ignorant, and ill-informed than Safer's. So I found myself wondering why the music and film communities could re-

spond to bourgeois punditry with such equanimity, while the French Academy and the contemporary art world went certifiably ga-ga. I came up with one answer. Music and movie people are not in denial about the frivolity of their endeavor, while the contemporary art world, like the French Academy, feels called upon to maintain the aura of spectacular unction that signifies public virtue, in hopes of maintaining its public patronage. It was like a *Brady Bunch* episode: "Accused of frivolous behavior and fearful of losing their allowance, the Brady kids take Holy Orders and appear on *Charlie Rose*. 30 min. Color."

So here's my suggestion: At this moment, with public patronage receding like the spring tide anyway and democracy supposedly proliferating throughout the art world, why don't all of us art-types summon up the moral courage to admit that what we do has no intrinsic value or virtue—that it has its moments and it has its functions, but otherwise, all things considered, in its ordinary state, unredeemed by courage and talent, it is a bad, silly, frivolous thing to do. We could do this, you know. And those moments and those functions would not be diminished in the least. Because the presumption of art's essential "goodness" is nothing more than a *political fiction* that we employ to solicit tax-payers' money for public art education, and for the public housing of works of art that we love so well, their existence is inseparable from the texture of the world in which we live.

These are worthy and indispensable projects. No society with half a heart would even think to ignore them. But the presumption of art's essential "goodness" is a conventional trope. It describes nothing. Art education is *not* redeeming for the vast majority of students, nor is art practice redeeming for the vast majority of artists. The "good" works of art that reside in our museums reside there not because they are "good," but because we love them. The political fiction of art's virtue means only this: The practice and exhibition of art has had beneficial public consequences in the past. It might in the future. So funding them is worth the bet. That's the argument; art is good, sort of, in a vague, general way. Seducing oneself into *believing* in art's intrinsic "goodness," however, is simply bad religion, no matter what the rewards. It is bad *cult* religion when professing one's belief in art's "goodness" becomes a condition of membership in the art community.

So consider for a moment the enormous benefits that would accrue to us all, if art were considered bad, silly, and frivolous. Imagine the *lightness* we would feel if this burden of hypocrisy were lifted from our shoulders—the sheer *joy* of it. We could stop insisting that art is a "good thing" in and of itself, stop pretending that it is a "good thing" to do—to do "good"—and stop recruiting the good, serious, well-educated children of the mercantile and professional classes to do it, on the grounds that they are too Protestant, too well-behaved, too respectful, and too desirous of our respect to effect any kind of delightful change. We could abandon our pose of thoughtful satiety, reconceive ourselves as the needy, disconsolate, and desiring creatures that we are, and dispense with this pervasive, pernicious, Martha Stewart canon of puritan taste with its disdain for "objects of virtue" and its cold passion for virtue itself.

We could just say: "Okay! You're right! Art is bad, silly, and frivolous. So what? Rock-and-roll is bad, silly, and frivolous. Movies are bad, silly, and frivolous. Basketball is bad, silly, and frivolous. Next question?" Wouldn't that open up the options a little for something really super?— for an orchid in the dung heap that would seem all the more super for our surprise at finding it there? And what if art were considered bad *for* us?— more like cocaine that gives us pleasure while intensifying our desires, and less like penicillin that promises to cure us all, if we maintain proper dosage, give it time, and don't expect miracles? Might not this empower artists to be more sensitive to the power and promise of what they do, to be more concerned with good effects than with dramatizing their good intentions?

What if works of art were considered to be what they actually are— frivolous objects or entities with no intrinsic value that only acquire value through a complex process of socialization during which some are empowered by an ongoing sequence of private, mercantile, journalistic, and institutional investments that are irrevocably extrinsic to them and to any intention they might embody? What if we admitted that, unlike seventeenth-century France, institutional and educational accreditation are presently insufficient to invest works of art with an aura of public import—that the only works of art that maintain themselves in public vogue are invariably invested with interest, enthusiasm, and volunteer

Dave Hickey

commitment from a complex constituency that is extrinsic both to themselves and to their sponsoring institutions?

If we do this, we can stop regarding the art world as a "world" or a "community" or a "market" and begin thinking of it as a semi-public, semi-mercantile, semi-institutional agora—an intermediate institution of civil society, like that of professional sports, within which issues of private desire and public virtue are negotiated and occasionally resolved. Because the art world is no more about *art* than the sports world is about *sport*. The sports world conducts an ongoing referendum on the manner in which we should cooperate and compete. The art world conducts an ongoing referendum on how things should look and the way we should look at things—or it would, if art were regarded as sports are, as a wasteful, privileged endeavor through which very serious issues are sorted out.

Because art doesn't matter. What matters is how things look and the way we look at them in a democracy—just as it matters how we compete and cooperate—if we do so in the sporadic, bucolic manner of professional baseball, or in the corporate, bureaucratic manner of professional football, or in the fluid, improvisatory manner of professional basketball. Because, finally, the art world is no more a community than Congress is a community, although, like Congress, it is in danger of *becoming* one and losing its status as a forum of contested values where we vote on the construction and constituency of the visible world. Works of art are candidates, aspiring to represent complex constituencies. So it is important that the value of art, *as* art, remains problematic—and equally important that none of us are disinterested in its consequences, or involved just for the "good" of art, which is not good. So consider these three benefits.

First, if art were considered a bad, silly, frivolous thing to do, works of art could fail. They could do so by failing to achieve a complex constitency—or by failing to sustain a visible level of commitment and socia ization—and this failure would be public and demonstrable, since every one involved would be committed to their own visual agendas and non to the virtue of "art." Such failure, then, would constitute an incentive t quit or to change—with the caveat that works of art with any constitu ency at all may sustain themselves in marginal esteem until, perhaps

their time has come. The practice of maintaining works of art in provisional esteem simply because they *are* works of art and art is good, however, robs artists of the primary benison of mercantile civilization: certifiable, undeniable, disastrous failure.

In warrior cultures there is no failure. There is only victory and death. In institutional cultures there is neither failure nor success, only the largesse or spite of one's superiors. Failure, however, is neither death nor the not-death of institutional life; it is simply the failure of one's peers (or the peer group to which one aspires) to exhibit any interest in or enthusiasm for one's endeavors. And there is no shame in this. In fact, such failures constitute the primary engine of social invention in Western societies, because these failures mean that you are wrong or that your friends are wrong. If you suspect that you are wrong, you change. If you think your friends are wrong, you change your friends, or, failing that, become a hobbyist. There is no shame in this, either.

Second, if art were considered a bad, silly, frivolous thing to do, art professionals, curators, museum directors, and other bureaucratic support-workers might cease parading among us like little tin saints—like Mother Teresa among the wretched of Calcutta—and our endeavors would be cleansed of the stink of their unctuous charity. Because if everyone's involvement in the frivolity of art were presumed to be to some extent self-interested, these caregivers would have to accept the obligation of taking care of *themselves* in pursuance of their own ends, and if these ends were just to hang around with artists and put on shows out of which nothing can sell, they could finance these purportedly public-spirited self-indulgences themselves.

This would abolish a fiction that is nowhere confirmed in my experience: that the art world is divided into "selfish commercial people" and "selfless *art* people"—the selfish commercial people being the artists, critics, dealers, and collectors who take the risks, produce the product, and draw no salary—the "selfless *art* people" being the disinterested, public-spirited, salaried support-workers, who take no risks, produce no product, and dare not even *buy* art with their art-derived salaries, lest they be guilty of "conflict of interest." The truth is that *everyone* is interested and self-interested and should be. Everyone waters their own little flower (although some do so at less risk than others). Moreover, *everyone*

Dave Hickey

is public-spirited: Everyone who waters their little flower tends the garden, as well, because no one is such a fool as to imagine their flower might flourish if the garden goes to seed.

Yet we continue to presume that honest virtue somehow inheres in those art functionaries who receive salaries, ideally from public sources, and that vice just naturally accrues to those who must live by their wits. Through the exquisite logic of Protestant economic determinism, virtue is ascribed to those who can afford to live nice, regular middle-class lives as a consequence of their submission to whatever authority dispenses their salary, and those who disdain such authority are, well, problematic. For the first time in history, in American art circles, the term "commercial artist" does not designate a guy who draws Nikes for *Sports Illustrated*. It designates an artist without a trust fund who has been unable to secure a grant or a teaching job.

If everyone declared their own self-interest, however, brought their own little flowers out of the hothouse and took responsibility for acquiring the wherewithal to water them, artists, critics, and dealers, who get paid by the piece, could stop parenting their self-appointed parents by donating their production to be frittered away or auctioned off by the support systems that supposedly support *them*—which, in fact, only erodes the market for the work donated and almost certainly insures the need for continued charity. Having said this, we must remember that presumptuous demands for theatrical gratitude by self-appointed caregivers are not local to the art world; they are the plague of this republic. The police complain that citizens don't support them; museums and alternative spaces complain that artists don't support them; radicals complain that workers don't support them; feminists complain that women don't support them. Nobody will do anything for anybody anymore, it seems, without a big hug in return. Yet, if such voluntary care constituted genuine advocacy, these demands would not be made. Thus, when they are made, they may be taken as self-serving and ignored. Making and selling and talking about art is simply too much fun and too much work to be poisoned by that perpetual begging whine: "We're only trying to help!"

Finally, if art were considered a bad, silly, frivolous thing to do, I could practice art criticism by participating in the street-level negotiation of value. I might disregard the distinctions between high and low art

and discuss objects and activities whose private desirability might be taken to have positive public consequences. As things stand, my function as a critic is purely secondary unless I am writing or talking about work in a commercial gallery. Otherwise, I am a vestigial spear-carrier in aid of normative agendas. In commercial galleries and artists' studios, the value of art is problematic by definition; and in these spaces, dealers, collectors, critics, and any other committed citizen who is willing to risk something enter into an earnest colloquy about what this silly, frivolous stuff might be worth.

If I praise a work in a commercial space, I invest words in it and risk my reputation. In doing so, I put pressure on the price by hopefully swaying public opinion. If I praise an exhibition in an institutional space, however, I am only confirming public policy. And since no art is for sale, I am really doing nothing more than the institution itself: giving the artist "exposure" (which should be a felony) and reinforcing the idea of art as a low-cost, risk-free spectator sport when in fact it is a betting sport. Thus, my institutional bets are nothing more than fodder for grant applications and résumés—a fact that becomes clear when I choose to detest an institutional exhibition, since, in doing so, I am questioning the fiduciary responsibility of expending public funds on such an exhibition and undermining the possibility of future funds. This, I have discovered, is taken very seriously indeed, although it has *nothing* to do with investing art with social value and everything to do with art's presumed, preordained virtue and the virtue of those who promote it.

So, I have been thinking, if art is "good" enough to be deserving of public patronage, just what does it do? I would suggest that since such work must be designed in compliance with extant legislation and regulatory protocols, it can only work on behalf of this legislation and those protocols. It can encourage us not just to obey the laws that we all fought so hard to pass, but to *believe* them, to internalize the regulatory norms of civil society into a "cultural belief system." Unfortunately, art that aspires to this goal is nothing more or less than *tribal art*, a steady-state hedge against change and a guarantee of oppression in the name of consensus, however benign.

To cite an instance: a young art professional, in aid of this tribal agenda, actually had the gall to use Robert S. McNamara's Vietnam-era

Dave Hickey

expression "winning their hearts and minds" in my presence. When I recovered from my flashback, I told her that, in my view, if you catch their eye, their hearts and minds will follow. She didn't even get the reference, and I could tell that it seemed perfectly reasonable to her that artists would subordinate their endeavors to the norms of "right-thinking people." This is good tribal thinking. In mercantile democracies, however, the practice of secular art, from Edouard Manet to Cindy Sherman, has invariably been the product of "wrong-thinking" made right. Because such works represent more than what they portray. They represent us in the realm of the visible, and if they represent enough of us, and if we care enough, yesterday's "wrong-thinking" can begin to look all right. It's a dangerous game, but it's the only one in town.

So, I'll tell you what I would like. I would like some bad-acting and wrong-thinking. I would like to see some art that is courageously silly and frivolous, that cannot be construed as anything else. I would like a bunch of twenty-three-year-old troublemakers to become so enthusiastic, so noisy, and so involved in some stupid, seductive, destructive brand of visual culture that I would feel called upon to rise up in righteous indignation, spewing vitriol, to bemoan the arrogance and self-indulgence of the younger generation and all of its artifacts. Then I would be really working, really doing my thing, and it would be so *great!* And it is *going* to happen, is already beginning to happen. The question is whether or not we will recognize it when it catches our eye.

John Berger

To Take Paper, to Draw

A World Through Lines

I sometimes have a dream in which I am my present age, with grown-up children and newspaper editors on the telephone, yet nevertheless have to leave and pass nine months of the year in the school where I was sent as a boy. In the dream, I think of these months as a regrettable exile, but it never occurs to me to refuse to go. In life, I ran away from that school when I was sixteen. The war was on and I went to London. Between the air-raid sirens and amid the debris of bombing I had a single idea: I wanted to draw naked women. All day long.

I was enrolled in an art school—there was not a lot of competition; nearly everyone over eighteen was in the services—and I drew in the daytime and I drew in the evenings. There was an exceptional teacher in the school at that time, an elderly painter, a refugee from fascism named Bernard Meninsky. He said very little and his breath smelled of dill pickles. On the same imperial-sized sheet of paper (paper was rationed; we had two sheets a day), beside my clumsy, unstudied, impetuous drawing, Bernard Meninsky would boldly draw a part of the model's body in such a way as to make clearer its endlessly subtle structure and movement. After he had gone, I would spend the next ten minutes, dumbfounded, looking from his drawing to the model and vice versa.

Thus I learned to question with my eyes the mystery of anatomy and

of love, whilst outside in the night sky, I heard the R.A.F. fighters crossing the city to intercept the German bombers before they reached the coast. The ankle of the foot on which her weight was posed was vertically under the dimple of her neck . . . directly vertical.

When I was in Istanbul recently, I asked my friends if they could arrange for me to meet the writer Latife Tekin. I had read a few translated extracts from two novels she had written about life in the shantytowns on the edge of the city. And the little I had read deeply impressed me with its imagination and authenticity. She herself must have been brought up in a shantytown. My friends arranged a dinner and Latife came. I do not speak Turkish, so naturally they offered to interpret. She was sitting beside me. Something made me tell my friends—no, don't bother, we'll manage somehow.

The two of us looked at each other with some suspicion. In another life I might have been an elderly police superintendent interrogating a pretty, shifty, fierce woman of thirty repeatedly picked up for larceny. In fact, in this our only life, we were both storytellers without a word in common. All we had were our observations, our habits of narration, our Aesopian sadness. Suspicion gave way to shyness.

I took out a notebook and did a drawing of myself as one of her readers. She drew a boat upside down to show she couldn't draw. I turned the paper around so it was the right way up. She made a drawing to show that her drawn boats always sank. I said there were birds at the bottom of the sea. She said there was an anchor in the sky. (Like everybody else at the table we were drinking raki.) Then she told me a story about the municipal bulldozers destroying the houses built in the night on the city's edge. I told her about an old woman who lived in a van. The more we drew, the quicker we understood. In the end we were laughing at our speed—even when the stories were monstrous or sad. She took a walnut and, dividing it in two, held it up to say—halves of the same brain! Then somebody put on some Bektaşi music and all the guests began to dance.

In the summer of 1916, Picasso drew on a page of a medium-sized sketchbook the torso of a nude woman. It is neither one of his invented figures—it hasn't enough bravura; nor is it a figure drawn from life—it hasn't enough of the idiosyncrasy of the immediate.

The face of the woman is unrecognizable, for the head is scarcely in-

dicated. However, the torso is a kind of face. It has a familiar expression. A face of love, become hesitant or sad. The drawing is distinct in feeling from others in the sketchbook. The other drawings play rough games with cubist or neo-classical devices, some looking back on the previous still-life period, others preparing for the Harlequin themes he would take up the following year when he did the decor for the ballet *Parade*. The torso of the woman is very fragile.

Usually Picasso drew with such verve and directness that every scribble reminds you of the act of drawing and of the pleasure of that act. It is this that makes his drawings insolent. Even the weeping faces of the *Guernica* period or the skulls he drew during the German Occupation possess an insolence. They know no servitude. The act of drawing them is triumphant.

The drawing in question is an exception. Half drawn—for Picasso didn't continue on it for long—half woman, half vase, half seen as by Ingres, half seen as by a child, the apparition of the figure counts for far more than the act of drawing. It is she, not the draftsman, who insists, insists by her very tentativeness.

My hunch is that in Picasso's imagination this drawing belonged somehow to Eva Gouel. She had died only six months earlier of tuberculosis. They had lived together—Eva and Picasso—for four years. Into his now famous cubist still lifes he had inserted and painted her name, transforming austere canvases into love letters. JOLIE EVA. Now she was dead and he was living alone. The image lies on the paper as in a memory.

This hesitant torso has come from another floor of experience, has come in the middle of a sleepless night and still retains its key to the door.

Perhaps these three stories suggest the three distinct ways in which drawings can function. There are those that study and question the visible; those that record and communicate ideas; and those done from memory. Even in front of drawings by the old masters, the distinction between the three is important, for each type survives in a different way. Each speaks in a different tense. To each we respond with a different capacity of imagination.

In the first kind of drawing (at one time such drawings were appro-

priately called *studies*), the lines on the paper are traces left behind by the artist's gaze which is ceaselessly leaving, going out, interrogating the strangeness, the enigma, of what is before his eyes—however ordinary and everyday this may be. The sum total of the lines on the paper narrates an optical emigration by which the artist, following his own gaze, settles on the person or tree or animal or mountain being drawn. And if the drawing succeeds he stays there forever.

In his study *Abdomen and Left Leg of a Nude Man Standing in Profile*, Leonardo is still there—there in the groin of the man, drawn with red chalk on a salmon-pink prepared paper, there in the hollow behind the knee, where the femoral biceps and the semi-membranous muscle separate to allow for the insertion of the twin calf muscles. And Jacques de Gheyn (who married the heiress Eva Stalpert van der Wielen and so could give up engraving) is still there in the astounding diaphanous wings of the dragonflies he drew with black chalk and brown ink for his friends at the University of Leyden around 1600.

If one forgets circumstantial details, technical means, kinds of paper, and so on, such drawings do not date, for the act of concentrated looking, of questioning the appearance of an object before one's eyes, has changed very little through the millennia. The ancient Egyptians stared at fish in a way comparable to the Byzantines on the Bosporus or to Matisse in the Mediterranean. What has changed, according to history and ideology, is the visual rendering of what artists dared not question: God, Power, Justice, Good, Evil. Trivia could always be visually questioned. This is why exceptional drawings of trivia carry with them their own "here and now," putting their humanity into relief.

Between 1603 and 1609 the Flemish draftsman and painter Roelandt Savery traveled in Central Europe. Eighty drawings of people in the street—marked with the title "Taken From Life"—have survived. Until recently they were thought to be by the great painter Pieter Bruegel.

One of them, drawn in Prague, depicts a beggar seated on the ground. He wears a black cap; wrapped round one of his feet is a white rag, over his shoulders a black cloak. He is staring ahead, very straight; his dark sullen eyes are at the same level as a dog's would be. His hat, upturned for money, is on the ground beside his bandaged foot. No comment, no other figure, no placing. A tramp of nearly four hundred years ago.

We encounter this today. Before this scrap of paper, only six inches square, we *come across* him as we might come across him on the way to the airport or on a grass bank of the highway above Latife's shantytown. One moment faces another and they are as close as two facing pages in today's unopened newspaper. A moment of 1607 and a moment of 1987. Time is obliterated by an eternal present. Tense: Present Indicative.

In the second category of drawings, the traffic, the *transport*, goes in the opposite direction. It is now a question of bringing to the paper what is already in the mind's eye. Delivery rather than emigration. Often such drawings were done as sketches or working drawings for paintings. They bring together, they arrange, they set a scene. Since there is no direct interrogation of the visible, they are far more dependent upon the dominant visual language of their period, and so are usually more datable in their essence—more narrowly qualifiable as Renaissance, Mannerist, eighteenth century, or whatever.

There are no confrontations, no encounters to be found in this category. Rather we look through a window onto a man's capacity to dream, to construct an alternative world in his imagination. And everything depends upon the space created within this alternative. Usually it is meager—the direct consequence of imitation, false virtuosity. Such meager drawings still possess an artisanal interest (through them we see how pictures were made and joined—like cabinets or clocks), but they do not speak directly to us. For this to happen the space created within the drawing has to seem as large as the earth's or the sky's space. Then we can feel the breath of life.

Poussin could create such a space; so could Rembrandt. That the achievement is rare in European drawing may be because such space only opens up when extraordinary mastery is combined with extraordinary modesty. To create such immense space with ink marks on a sheet of paper one has to know oneself to be very small.

Such drawings are visions of *what would be if*.... Most record visions of the past which are now closed to us, like private gardens. When there is enough space, the vision remains open and we enter. Tense: Conditional.

*

John Berger

Finally, there are the drawings done from memory. Many are notes jotted down for later use—a way of collecting and of keeping impressions and information. We look at them with curiosity if we are interested in the artist or the historical subject. (In the fifteenth century the wooden rakes used for raking up hay were exactly the same as those still used in the mountains where I live.)

The most important drawings in this category, however, are made (as was probably the case in the Picasso sketchbook) in order to exorcise a memory which is haunting—in order to take an image out of the mind, once and for all, and put it on paper. The unbearable image may be sweet, sad, frightening, attractive, cruel. Each has its own way of being unbearable.

The artist in whose work this mode of drawing is most obvious is Goya. He made drawing after drawing in a spirit of exorcism. Sometimes his subject was a prisoner being tortured during the Inquisition to exorcise his or her sins: a double, terrible exorcism.

I see a red wash and sanguine drawing by Goya of a woman in prison. She is chained by her ankles to the wall. Her shoes have holes in them. She lies on her side. Her skirt is pulled up above her knees. She bends her arm over her face and eyes so she need not see where she is. The drawn page is like a stain on the stone floor on which she is lying. And it is indelible.

There is no bringing together here, no setting of a scene. Nor is there any questioning of the visible. The drawing simply declares: I saw this. Historic Past Tense.

A drawing from any of the three categories, when it is sufficiently inspired, when it becomes miraculous, acquires another temporal dimension. The miracle begins with the basic fact that drawings, unlike paintings, are usually monochrome.

Paintings with their colors, their tonalities, their extensive light and shade, compete with nature. They try to seduce the visible, to *solicit* the scene painted. Drawings cannot do this. They are diagrammatic; that is their virtue. Drawings are only notes on paper. (The sheets rationed during the war! The paper napkin folded into the form of a boat and put into a raki glass where it sank.) The secret is the paper.

The paper becomes what we see through the lines, and yet remains itself. A drawing made around 1553 by Pieter Bruegel is identified in the catalogues as a *Mountain Landscape with a River, Village and Castle.* (In reproduction its quality will be fatally lost: better to describe it.) It was drawn with brown inks and wash. The gradations of the pale wash are very slight. The paper lends itself between the lines to becoming tree, stone, grass, water, cloud. Yet it can never for an instant be confused with the substance of any of these things, for evidently and emphatically, it remains a sheet of paper with fine lines drawn upon it.

This is both so obvious and, if one reflects upon it, so strange that it is hard to grasp. There are certain paintings which animals could read. No animal could ever read a drawing.

In a few great drawings, like the Bruegel landscape, everything appears to exist in space, the complexity of everything vibrates—yet what one is looking at is only a project on paper. Reality and project become inseparable. One finds oneself on the threshold before the creation of the world. Such drawings, using the Future Tense, *foresee*, forever.

Mark Doty

The Panorama Mesdag

A mile or so from the Mauritshaus, which is the serious museum in The Hague—or Den Haag, as the Netherlanders call it—is another museum, a startling and eccentric one.

The Mauritshaus is a seventeenth-century palace, full of Rembrandts, and two splendid Vermeers, and one of the only extant paintings of Carl Fabritius, a man who may have been Vermeer's teacher. He died at twenty-three, in Antwerp, when a powder keg exploded, and one of the few things he left behind is this small rectangle of canvas depicting a goldfinch chained by the ankle to an iron hoop embedded in a wall of yellowish plaster. Wall and bird are somehow palpably *there*, and distinctly paint as well, so they seem strangely fresh, as ambiguous and fragmentary as they must have the day they were painted, nearly four hundred years ago.

The day we visited the grand building was surrounded by scaffolding, all but the windows wrapped in billowing sheets of plastic. The cool, orderly rooms, their walls covered in dark damasks, look out onto a geometry of ponds and the orderly brick courtyards of public buildings, but that morning in each window a man in coveralls was scraping or painting, and out in the front courtyard two workers pursued the exacting task of goldleafing the spear-points of the wrought iron fence, one ap-

plying mastic, the other lifting thin, ragged sheets of metal into place. They stopped when the intermittent rain grew too heavy, and resumed again as soon as it cleared a little, sunlight breaking through onto the courtyard where the iron pickets they'd finished were gleaming with a startling brightness.

No gold, and no Vermeers, distinguish the Panorama Mesdag, which is found by following street signs from the great museum through some handsome downtown streets, turning onto a quiet edge of the commercial district. It's a curiosity, only to be visited by people with extra time, perhaps more a folly than a work of art exactly. Though what the guidebooks don't tell you is that Hendrik Willem Mesdag's circular extravaganza of a painting is also a parable, a meditation on limit, on what art might and might not achieve. And that, in the strange way that souvenirs of gone ambitions do, it gets under your skin.

If Carl Fabritius is the type of the artistic life truncated—vanished before his abilities could come to full bloom, the tiny goldfinch, alert and sad at once, looking off away from us the calling card of his genius—then Mesdag is the opposite, a man whose long artistic life was fulfilled, complete, conducted in public, attended by honors and professional recognitions that must have come to encase him like a very solid suit, an armor of reputation and regard. He was the very type of the successful nineteenth-century painter, the artist as businessman, his achievements held in high public regard, not open to doubt. Mesdag (pronounced Mes-dách, with that *ch* catching in the throat as in the Scottish *loch*) built his own museum, attached to his own house, in which he planned to display both his own work and the rather murky fin-de-siècle paintings he collected. Some of these aren't bad, and some of them are completely hilarious, especially a suite of Italian symbolist pictures representing fauns and nymphs caught in moments of candescent desire, leering out from messy swathes of paint. Mesdag had shaky taste, and he wasn't a good painter, either. He had his moments, in big horizontal landscapes that seem lit by a love for the Dutch countryside's peculiar horizontality: big flat fields, divided into bands of color, grainfields, bulb fields, bands of canal. Strips of color intricately fitted together, like marquetry, under wide, lively

Mark Doty

skies in which huge clouds move in from the North Sea, incandescent patches of blue opening between them.

But what made Mesdag famous, unfortunately, were seascapes. The dunes began just outside Den Haag in those days, and they rolled to the adjacent coastal town of Scheveningen, and the painter liked nothing better than portraying the swelling, roiling surface of the sea. He perfected a technique for this that seems to have more to do with an idea of the marine, or a feeling about it, than with observation; my immediate response to his seascapes was to wonder how a painting of waves could be sentimental. Where does that quality reside? But sentimental they are; they make it very clear that Mr. Mesdag felt much more about his briny scene than we do. The paintings have everything to do with his desire to present the sea, or his own virtuosity in representing it, and nothing to do with the sea itself—the performance feels hollow, a quality doubtless enhanced by repetition. And repeat he did, generating for an eager market big, turbid seascapes in ponderous gilt frames.

But his Panorama is quite another thing. Unframed, continuous, borderless, the Panorama confounds the powers of description. In a wonderful book on Dutch painting and culture in the seventeenth century called *Still Life with Bridle*, the Polish poet Zbigniew Herbert points out that language must go to great lengths to accomplish a mere replica of what painting does in an instant; arranging sentences to describe a canvas, he writes, is like hauling heavy furniture around a room. And indeed Mesdag's Panorama makes me feel I must now muster a whole household of verbal furnishings—bottom to top, cellar to attic—and lug them about the page in order to give some sense of his project's peculiar presence.

It is housed in a building of its own, designed exclusively for this purpose—a fact that points to the collaborative nature of the thing, in which Sientje Mesdag-van Houten, Mesdag's wife, was also involved, as well as an architect and a number of other Den Haag painters. The Panorama isn't entirely anomalous; there was a bit of a fashion for them, in the late nineteenth century, when they were also called "cycloramas"—circular, sweeping paintings of large views. They were associated with exhibitions and large fairs; other examples represented Jerusalem and the awe-

some chasms of Niagara. In truth, the Panorama wasn't Mesdag's idea at all; he was commissioned to paint it by a panorama company, which must have intended to build an attraction rather than a work of art, though just at that moment the distinction between the two may not have been a firm one. It's odd to think of a painter taking on such an immense, flashy commission, agreeing to create a wonder, a tourist attraction. Did Mesdag know from the beginning he'd create something peculiar, enduring, ambiguous?

The building is of gray stone, big and square, and the door leads through entrance galleries full of bad Mesdags and antique Panorama souvenirs displayed in glass cases to the ticket counter, where two kind Dutch ladies and one pleasant, homosexual Dutch gentleman are waiting to take our guilders and provide us with brochures. The patrons trickling in don't seem your usual art museum consumers; mostly families with kids, mostly Dutch themselves; this place isn't high on the foreign traveler's list. Down a flight of stairs, around a narrow curving hallway, painted black, and soon we're on another, spiral stair, which is leading us up into the great chamber of the panorama itself.

Where to begin? The first impression is of light, cloudy daylight, which is not only coming from above but oddly ambient, in the way light really is at the seashore, reflecting from sand and water. And we *are* at the shore, or at least at a version of it, because the structure into which we have emerged from up the winding stair is a large beach pavilion, of wood, with a conical roof of thatch of some kind. Our pavilion—a simple round gazebo—is atop a hill of sand, and from it we look out, 360 degrees, as the sand descends, dotted with dry bits of beach grass and driftwood, to ... what? A painting, a huge painting, which is wrapped all around us, and which represents the North Sea, reaching out to vast distances where light breaks through those towering clouds, and the shore, where boats are clustered, and where people walk, and the dunes, and upon them the town of Scheveningen, with its summer houses and its chapels, its pleasure pavilion and hotels and music hall. A world, in other words, in which we are standing at the center. It smells like sand, dry old sand, and there is even a recording of seagulls and distant waves.

It is not a very good painting, it turns out, but it is a very good illu-

sion. Because the bottom of the painting is obscured by sand and grass and bits of flotsam, and is some ways away from us as well, it seems to rise seamlessly out of the earth. Because the top is covered by the jutting vegetable roof of the pavilion in which we stand, the painting *has no edges*. It is unbroken, uninterruptible. And when you take a step forward or back, the experience is nothing like approaching or retreating from a painting hung on a wall; instead, weirdly, you realize instead you are *inside* of something. The "world" around you is a work of art, and you are its center.

That center is strangely, unnervingly unstable, because every way you step your perspective changes a little. Not in the effortless way it does in the world outside; within this strange hothouse of a theater there's a disorienting little adjustment every time Paul and I move. Our eyes readjust in relation to a new perspective on an illusion. The focus of our attention shifts: that woman with the white umbrella on the beach (who turns out to be Sientje Mesdag), those sailboats far out in the bluegreen shallows. And over it all sky and sky, endless, complicated by grand marine clouds, whole armadas of them. Where is all this light coming from, and why does it keep shifting in these swift and subtle ways?

There's an oculus in the ceiling, hidden by the pavilion's roof, that bathes this world in natural light, and because it's a day of rapidly shifting weather, the light inside pulses and changes as those clouds—prototypes of the billows forever frozen in here—hurry overhead, themselves like heavy, graceful ships.

And the effect of all this effort?

A weird sense of being transported into an illusory space, like the dicey three-dimensionality of a stereopticon slide, or the fuzzy depths of a hologram. Something inescapably false about it, and something endearing about that falsity. Something childlike? Quasi-scientific, in a sort of gee-whiz nineteenth-century way, something that would have earned the admiration of Jules Verne. A sense of a rather comical arrogance, the result of the artist's ambition to get closer and closer to reality? *I'll make a painting that seems as large as the world!* Walt Disney said that his "audioanimatronic" figures—the walking, talking Mr. Lincoln, for instance, a robotic Madame Tussaud manikin—were art's highest achievement,

because they were the closest art had yet come to the real. There's something endearingly quaint about the notion, provincial as Scheveningen, doomed to failure.

And yet the Panorama Mesdag doesn't fail, not exactly, since it has this odd, unsettling power. Of what sort, exactly?

The Panorama denies the tyranny of the frame. We're used to art held in its place, contained, nailed to the wall, separated from the world by a golden boundary that enhances and imprisons it. What if art refused to stop there, on the museum wall? Wouldn't the result be revolution?

A great ambition, to take us inside, for art to subsume reality.

Fabritius vs. Mesdag; the former is tiny, bounded. We are in control, we walk away and turn our attention elsewhere. The painting has edges; the shadow of the finch is headless, jutting out of the frame to the right; the painting doesn't try to include everything. It occupies only its own space, contained, in some way indifferent to us. There it is, whether you look at it or not. It bears its signature proudly, as though it were inscribed in stone: *C Fabritius 1654.*

But even that bold signature seems modest in the face of Mesdag's hubris. Carl Fabritius is quite content to represent one bird, and to fill that little feathered vessel with feeling of a decidedly ambiguous, poetic sort. He is deeply concerned with light on a patch of plaster no larger than, say, the Yellow Pages. While Mr. Mesdag requires nothing less than a universe, his only limit the unbanishable edge of the horizon. If he could get rid of the horizon, one guesses, he would.

But how unpressurized art is without its frame! This big, encompassing gesture fails to move. Well, that's not entirely true; it seems that everyone mounting the dark stairs and stepping out into the filtered light of this grand theatrical space feels something: awe, amusement, surprise? But it couldn't make anyone weep, could it, except perhaps at the folly of human pride?

The brochure says after its first hundred years the Panorama was in sorry shape, and a team of experts came to restore it: cleaning, restretch-

ing the great canvas on its circle of poles, retouching where necessary. Queen Beatrix was here for the final brushstroke. "We would have lost our beautiful Panorama," the text says, touchingly including us all in the sad prospect that has been so fortunately averted.

But I confess: I would have loved the Panorama more in disarray; I'd have loved to have seen it with stains of mildew creeping through its skies, or a worry of unraveling the mice had done down in the sands beneath the high dunes of Scheveningen. Then, in the face of time's delicate ruination of human ambition, I would have been moved.

Could he have known his work would become history? At the moment of its conception, when he made his original sketch, then transferred it to a glass cylinder, and shone a strong light through it to project the rough sketch onto the huge suspended canvas, he was recording how Scheveningen looked—its actual present. It's the action of time, not of the painter, that's made it quaint, historical, an artifact. Look around you, right now, turning in a circle from where you sit. Suppose what you see in this circle, from your body to your horizon, were recorded, on canvas, or in a photograph: in a hundred years it would be a history of your moment, of the daily surround. It would have passed out of the realm of the ordinary, the familiar become not quite imaginable, unreal.

Later, I ask Paul what he thinks the Panorama is about. He says, "Instability, everything in flux. Everywhere you step it all seems to shift, the light looks different. And weather! That looming dark storm hurrying in."

"What storm?" I say. "I don't remember a storm."

"There's a storm," he says, "coming in over the village, and it's terrifically dark."

I find the brochure I've bought, a fold-out panorama of the Panorama that seems to flatten the whole thing out, darken it and place it more firmly in the nineteenth century. It looks like a big stage backdrop for an operetta. There's some shading in the clouds, over the buildings the brochure identifies as the Pavilion VonWied and the Hotel des Galeries, but hardly a storm. "In the original," Paul says, "those clouds are *much* darker."

I say I think the Panorama is about hubris, about the limitless ambitions of art, which here have become a kind of joke. But then I think, no. A beautiful and moving joke.

The sweeping novel that contains a world, the epic poem that entirely believes in itself, the house in which every element bears the hallmark of its maker—those things all seem historical. We've lost such ambitions; no one believes in them quite. Either we don't live in a moment that allows for such coherence, or else we're terrified of the broader vision. Are we collectively holding at bay the awareness of a gathering apocalypse? And so prefer a poetry of interiority, a painting safely ironic and self-referential, a fiction of limited means? Should we try to be Mesdags?

On the evidence of this painting, no; the effort partakes too much of the city council, of civic pride, of public ceremonies, a kind of bourgeois boosterism. I imagine Mesdag and company being presented with medallions hung on ribbons while a brass band plays. One misses an art of intimacy, of privacy, of emotional urgency and connection. There's something hollow and flimsy about the grand gesture.

And yet. There is something I miss about the scale of the ambition, something lovely about the longing the project represents: *here is the world around me this minute, all of it.*

In fact, the Panorama isn't much like a painting. It's like a poem. It wishes to place you in the center of a moment, wishes to colonize your attention for a while, while time seems held in suspension. A ring whose center is everywhere and whose circumference is nowhere. Well, the painting's circumference is *there*, a fact in space, but it doesn't seem to be—these skyey horizons open on and on. It's an ancient figure for the divine, the circle whose rim we can't find, can't reach, which seems to have no outer limit.

We step outside. It's raining a little more energetically, people pulling out umbrellas or pulling jackets and anoraks up over their heads. I have a plastic bag full of postcards, including my pull-out brochure of the entire panorama in the form of an antique tinted photograph seen in the mode of early in this century. Also in the bag is the souvenir Paul's bought—a

Mark Doty

little plastic TV set with a tiny peephole on the back side; you hold it up to the light and—voila!—there's a little 3-D view of a portion of the Panorama. Click a button on top and another view slides into place. Like the Panorama itself, this little perspective box seems part and parcel of the Dutch love of illusion, a long-standing fascination with the intricacies of seeing. Trompe l'oeil, still life, the minute gestures of the painter rendering the silvery lip of an opened oyster, the translucent jelly of a ripe gooseberry. Anamorphosis, those peculiar paintings that are unreadable till reflected in a curving mirror. And the more pragmatic applications of this fascination: lenses, ground and set into microscopes and telescopes. Gifts of vision, without which the disposable contact lenses I wear, curved to the steep pitch of my cornea and weighted so as to correct, in each eye, a different degree of astigmatism, would not exist. Without them, the tricks and subtleties of Mesdag—or Fabritius or Vermeer for that matter—would be lost on me.

Paul's little aqua blue television set reminds me of Proust's magic lantern—wavery images, on the remembered walls, the stuff of legend and daydream. Now the Panorama Mesdag's filtered through another layer of nostalgia: these plastic TV sets were popular in America in the early sixties. I remember buying one at the Grand Canyon; Paul brought them home from junky tourist shops in Florida or the Jersey shore.

Did Mesdag intuit that his subject, no matter what he intended it to be, would become memory? Everyone who enters this pavilion returns to some original, interiorized beach, memory's shoreline: crash and back-suck of wave, sunlight, sudden cool approach of a cloud's shadow, salt-scent and foam and bits of shell. Textures of sand, crook of an arm, curve of a shoulder. Layers of memory, narratives made out of the slipstream of impressions in time: this is the circle in which I stood. Sunflower petals rayed around the center's furled whorls. This is what seemed to radiate around me, this is the world I arranged merely by standing in the center of my life.

Each man or woman or child who mounts the curving stair into Mesdag's dream palace enters something in the collective memory—here was a beach town, just as it was, in 1881. And here is something of how we understood ourselves, in the last century's twilight, our pleasures and our ambitions. And we understand then, perhaps without saying it to

ourselves, that our moment's just as fleeting, just as certain to seem antique and quaintly lit; that we become, in time, one of those figures on the shore, not very detailed, not particularly individual, a representative of our era, when seen from such a distancing perspective. Oddly paradoxical, and oddly moving—to be reminded that we stand at the center of our own lives, and that those lives are historical, and fleeting. What could the effect be, then, but tenderness?

Now we stand on the wet street, Paul and I, in the center of a realm of light and shadow—reflections off wet cars, a "walk" sign distorted in a puddle over cobblestone—and anyway we step that world shifts around us, an optical paradox. Already I seem to be recognizing that the Panorama is better in memory—less quaint, more profound, more troubling, not a large bad painting but an accomplished chamber of recollection, a parable, something to keep. We're walking back toward the train station, carrying our souvenirs. Our shoulders keep touching as we walk along the sidewalk. I'm aware of our paired steps, this cool late afternoon, the physical fact of us, his body, mine, how even in motion we seem to stand in the center of circle after circle. Having been in a Panorama once, it seems we never entirely leave.

Mark Doty

contributors

Dorothy Allison's most recent novel is *Cavedweller.* She is the author of *Trash; The Women Who Hate Me; Skin: Talking About Sex, Class and Literature; Two or Three Things I Know for Sure;* and *Bastard Out of Carolina,* the acclaimed best-seller and a finalist for the National Book Award. She lives in San Francisco.

Hilton Als is a staff writer for *The New Yorker* and author of *The Women.* He lives in New York City.

Jennifer Belle is the author of the novel *Going Down,* which was translated into many languages and optioned for the screen by Madonna. Her second novel, *High Maintenance,* is forthcoming from Riverhead. She is an editor at the literary magazine *Mudfish.*

John Berger is a celebrated art critic, novelist, screenwriter, and painter. He lives in France.

Arthur C. Danto is Johnsonian Professor of Philosophy Emeritus at Columbia University, art critic for the *Nation,* and the author of many books about art and philosophy.

Mark Doty is the author of five books of poems and two memoirs. A Guggenheim, Ingram-Merrill, and Whiting Fellow, he has also received the National Book Critics Circle Award and the PEN/Martha Allrand Prize for Nonfiction.

Wendy Ewald is an artist-writer who has taught in Appalachia, Colombia, South Africa, Mexico, Morocco, and Saudi Arabia, as well as in various communities in the

United States. She is currently a research associate at Duke University's Centers for International and Documentary Studies. In 1992 she was awarded a MacArthur fellowship. *Secret Games*, a thirty-year retrospective of Ewald's work, will be published by Scalo in 2000.

Laurie Fendrich is a painter who lives and works in New York. She is associate professor of fine arts at Hofstra University in Hempstead, New York. After graduation from Mount Holyoke College with a degree in political science, she received her MFA from the School of the Art Institute of Chicago.

Mary Gordon is the author of the best-selling novels *Final Payments, The Company of Women, Men and Angels, The Other Side, Spending,* and a memoir, *The Shadow Man.* She has published a book of novellas, *The Rest of Life,* a collection of stories, *Temporary Shelter,* and a book of essays, *Good Boys and Dead Girls.* Her most recent collection of essays, *Seeing Through Places,* will be published in January of 2000. She has received the Lila Acheson Wallace Reader's Digest Award and a Guggenheim Fellowship. She is a professor of English at Barnard College.

Dave Hickey is the author of *Prior Convictions, The Invisible Dragon,* and *Air Guitar.* He received the Frank Jewett Mather Award for Distinction in Art Criticism in 1994 and is currently professor of art criticism and theory at the University of Nevada–Las Vegas.

bell hooks is the author of many books, including *All About Love, Outlaw Culture, Teaching to Transgress,* and *Art on My Mind.* A Distinguished Professor of English at City College in New York, she lives in Greenwich Village.

The late **Alfred Kazin** was one of America's most prominent critics and scholars. He was the author of many books, including *On Native Grounds, A Walker in the City, New York Jew,* and *God and the American Writer.*

Lucy R. Lippard's books include *Mixed Blessings, On the Beaten Track, The Lure of the Local, Overlay,* and *The Pink Glass Swan.* She has been a columnist for the *Village Voice, In These Times,* and *Z Magazine.* She lives in Galisteo, New Mexico, and Georgetown, Maine.

Jed Perl is the art critic for the *New Republic.* His latest book, *Eyewitness,* is forthcoming from Basic Books. He lives in New York City.

Peter Schjeldahl is the art critic for *The New Yorker.* His books include *The Hydrogen Jukebox: Selected Writings of Peter Schjeldahl, 1978–1990* and *Columns and Catalogues.*

August Wilson is at work on a series of plays about the black experience in America. He is the recipient of many awards, including Pulitzer Prizes for *Fences* and *The Piano Lesson.* He lives in Seattle, Washington.

ACKNOWLEDGMENT

Many thanks to Amy Blair for her help in shaping this project at its early stage.